the KODAK Workshop Series
Existing-Light Photography

the KODAK Workshop Series

Helping to expand your understanding of photography

Existing-Light Photography

Third Edition 1996, Third Printing 2001

Original edition by Hubert C. Birnbaum
Cover photo by Flip Chalfant
Back cover photo by Steve Kelly

ISBN 0-87985-744-7

Publication KW-17
Cat. No. E144 1179

Printed in the United States of America

Kodak
LICENSED PRODUCT

KODAK is a trademark of Eastman Kodak Company used under license.
EKTAR, ROYAL, GOLD, EKTACHROME, KODACHROME, T-MAX, TRI-X,
TECHNIDOL, EKTAPRESS, VERICHROME, PLUS-X, T-GRAIN, FLEXICOLOR,
PANALURE, DATAGUIDE, D-76, and HC-110 are trademarks of Eastman Kodak Company.

The Kodak materials described in this book are available from those dealers
normally supplying Kodak products. Other materials may be used, but equivalent results
may not be obtained.

Library of Congress Catalog Card Number 96-69137

KODAK Books are published under license
from Eastman Kodak Company by

Silver Pixel Press®
A Tiffen® Company
21 Jet View Drive
Rochester, NY 14624
Fax: (716) 328-5078
www.silverpixelpress.com

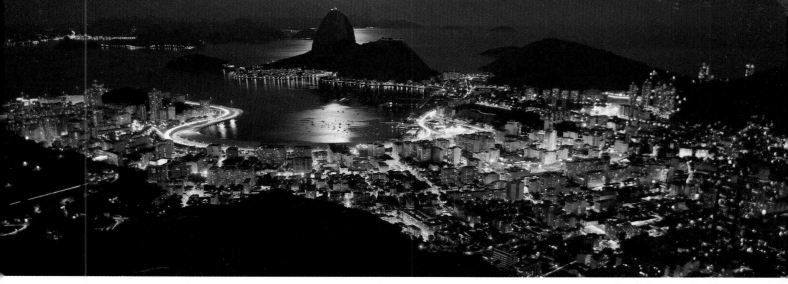

Rio de Janeiro, Brazil
Neil Montanus

Contents

Introduction

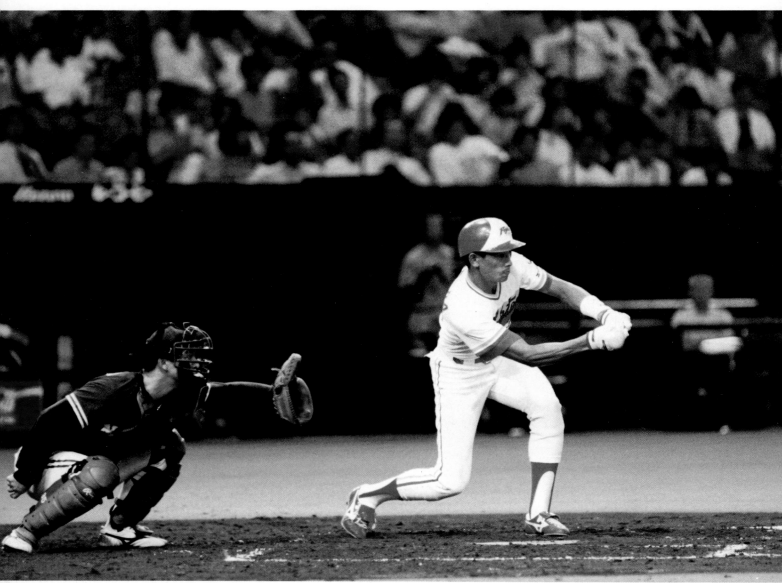

Sam Campanaro

1000-speed film allows you to use higher shutter speeds to stop action or handhold telephoto lenses, or to set small apertures for increased depth of field.

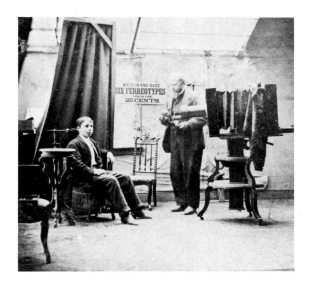

Slow photographic plates and films and relatively small-aperture slow-speed lenses made it difficult to take good existing-light pictures in the early days of photography. Neither camera nor subject could move during the long exposures required, as in this example made in the 1860's.

International Museum of Photography
at George Eastman House

In the early days of photography, the ability to make attractive, natural-looking photographs in existing subdued lighting was a tantalizing dream. Lenses of limited light-gathering ability and relatively insensitive plates and films tended to discourage all but the most skilled photographers from attempting to record other than fully lighted outdoor subjects in bright daylight. Many familiar sights and events were off-limits to most photographers because they took place too early or too late in the day or because they occurred indoors beyond the reach of daylight. Modern high-speed lenses and sensitive high-speed films have shattered these limitations of time and place, expanding the photographers' world beyond the dreams of their predecessors. Today, with few exceptions, if you can see it, you can photograph it. And it is much easier than you might imagine. In the following pages you'll find practical techniques for taking good pictures in the vast and fascinating world that begins where bright outdoor daylight ends. It is the world of existing-light photography.

High-speed film is designed for low light and fast action.

Joseph Janowicz

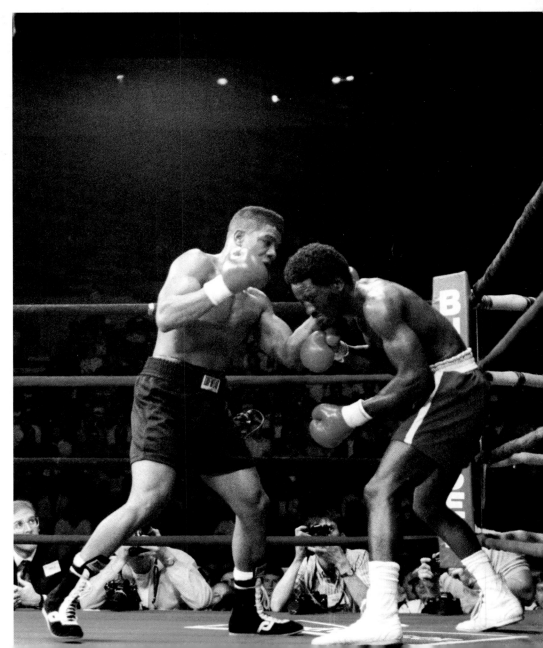

Existing-Light Photography

The term "existing-light photography" is difficult to define because it encompasses so much and because its definition is an arbitrary one. First of all, it is photography performed primarily with illumination that naturally exists in the scene. It is usually photography performed under relatively subdued lighting. In terms of these conditions, the only light sources that don't qualify are bright outdoor daylight and artificial lights that you introduce into the scene as primary sources of illumination. Living-room lamps, fluorescent lights in stores and offices, arc lights at a circus or ice show, vapor lamps on city streets, lighted signs, firelight from a campfire, skylight flooding through a window, and candles flickering on a restaurant table are all examples of existing-light sources.

Skylight—Daylight

Bob Clemens

Arc Lights, Ice Capades, Inc.

Kevin Krings

Living-Room Lamps—Tungsten Light

Fluorescent Lights

Norm Kerr

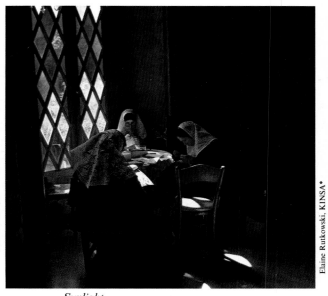

Sunlight

Elaine Rutkowski, KINSA*

*Courtesy Kodak International Newspaper Snapshot Awards

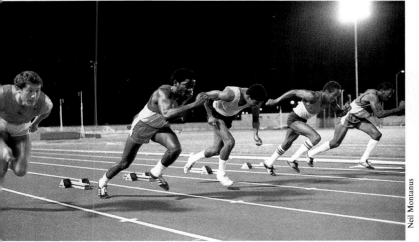

Vapor Lamps

Neil Montanus

Outdoors at Night—Twilight Neil Montanus

Candlelight

Brian Speer

Existing light is the light inherent in the scene, whatever it may be. It is less bright than most outdoor daylight conditions and is often quite dim.

Technically, existing light covers all natural lighting—from moonlight to bright sunshine. For photography, though, we're going to limit the definition of existing light to mean lighting situations characterized by lower light levels that require considerably more exposure than subjects in most outdoor daylight lighting conditions require. Photography in outdoor daylight is excluded from the existing-light category because basic picture-taking can be done in daylight with all cameras without the special techniques required for low-light situations. If the term existing light included outdoor daylight, it would lose its meaning.

Existing-light photography is sometimes called "available-light photography." In this book, we'll use "existing light," because the word "available" opens a large loophole. Any extraneous lighting a photographer chooses to use or take along could be considered available, even if it becomes the primary light source. The term existing-light photography is less ambiguous. Note too, that some photographers, in deference to the dim light typical of many existing-light situations, have also dubbed it "unavailable-light photography." It does seem that way sometimes.

Existing-Light Pleasures and Perils

One of the best reasons for photographing by existing light is that the pictures have a natural look that is extremely difficult or impossible to recreate with contrived lighting. Existing-light photographs are unexcelled for preserving the mood of a scene. The picture will nearly always evoke the feelings you associated with the natural appearance of the setting and reveal the people and other subjects realistically.

The cloud that accompanies the silver lining is that illumination we consider perfectly acceptable as part of a particular environment, such as the lighting in

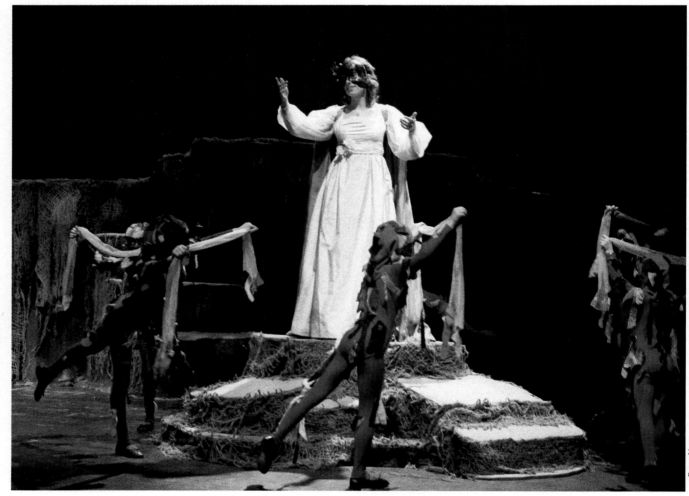

Bruce Nett

homes, in the work place, in public places indoors, and outdoors at night, may be marginal or worse in photographic terms. While the existing illumination is usually sufficient for its intended purpose of lighting the environment, it's often contrasty, uneven, and dim for photography. In the following pages you will learn to cope with many of the less favorable characteristics of existing light. For the moment, though, let's accept the premise that even an exceptionally attractive existing-light photograph will often not embody all the photographic virtues of high technical quality and perfection that you would expect in an artfully contrived studio simulation of a similar scene. The

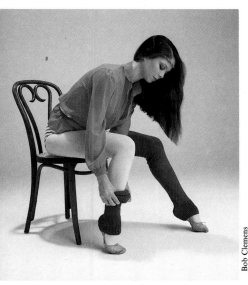

The natural look is the hallmark of existing-light photographs. Here, an existing-light picture of a play (left) is technically less elegant, but more realistic looking, than a professionally lighted and arranged studio photograph of a dancer made by a professional photographer. Both photos are excellent examples but represent two different approaches to photography.

outstanding attribute of existing-light photography is its natural portrayal of the scene. This usually more than compensates for some necessary compromise in technical quality to achieve this kind of photograph.

Sometimes using existing light is the only practical way to photograph a subject. It's usually not possible to use flash to photograph scenes such as large building interiors or distant lighted subjects outdoors at night. The light from the flash just won't reach that far.

TWO BASIC WAYS TO USE EXISTING LIGHT

There are two fundamentally different approaches you can take to existing-light photography. Most photographers use both, choosing one or the other according to circumstances and photographic intent.

The first might be characterized as a journalistic approach, in which photographers use large-aperture high-speed lenses and high-speed films to permit shooting freely with a hand-held camera. This method allows you great freedom of movement and encourages spontaneous shooting that can result in photographs of great charm and vitality. You can aim your camera freely and not be encumbered by using a camera support. To many photographers, existing-light photography is synonymous with the journalistic approach.

The second way of photographing by existing light is a more traditional approach, since it is reminiscent of the methods all photographers used in the early days before high-speed lenses and films were available. With this technique, you put your camera on a tripod or other firm camera support for maximum steadiness and use relatively slow shutter speeds or time exposures. This lets you use almost any lens, since you may be using a moderate to small aperture to enhance depth of field and a medium- or low-speed film for optimum sharpness and freedom from graininess. See the picture on the next page. These films usually have better sharpness and graininess characteristics than higher-speed film. In exchange for giving up journalistic freedom of movement, you may be able to make sharper, finer-grained pictures with improved depth of field. These photo-

Flash pictures, while adequate to record many scenes, have an artificial appearance due to the flat, frontal lighting (top). Existing-light pictures taken in the natural lighting are much better at portraying scenes as they appear.

Gary Whelpley

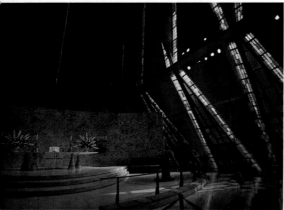

Keith Boas

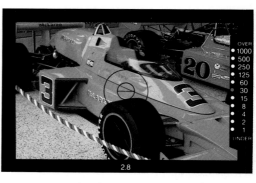

Caroline Grimes

2.8

High-speed films and large-aperture lenses let you photograph freely with a hand-held camera to capture the vibrancy of life around you, much as a photojournalist would. The journalistic approach lets you take pictures rapidly, conveniently and unobtrusively, and in locations where camera supports or flash may be impractical or may not be permitted.

A medium-speed, fine-grain film, KODACHROME 64 Film (Daylight), recorded this scene very sharply, preserving fine detail, during a relatively long exposure made with a slow shutter speed. The camera was mounted on a tripod.

CAMERAS FOR EXISTING-LIGHT PHOTOGRAPHY

Strictly speaking, almost any camera in proper operating condition is capable of making acceptable pictures under some existing-light circumstances. However, if you want to deal with the broad spectrum of existing-light situations efficiently and conveniently, consider the following capabilities.

Single-lens reflex cameras are excellent cameras for existing-light photography because they have through-the-lens viewing and focusing, precise viewfinder framing, and the capability for using interchangeable lenses. Most importantly, they offer great control in regulating the light coming into the camera.

Although only a few models are being sold, rangefinder cameras are also a good choice for existing-light photos. These non-SLR cameras have direct optical viewfinders, feature fast, accurate focusing, quiet operation, small size, and light weight. They are less obtrusive for candid shots and are easy to carry.

Non-SLR cameras with automatic focusing offer many of the same advantages as rangefinder cameras. But many have a distinct disadvantage: restricted regulation of light coming into the camera. You can't adjust exposure or override the camera's exposure setting. The lens' largest maximum aperture usually is fairly large, making it difficult to get pictures in very dim light.

A camera that lets you compose and focus quickly and easily in dim light is an advantage in existing-light photography. And the clearer the display of camera functions, the better. With an SLR camera, a high-speed lens with a large maximum lens opening helps make the viewfinder image brighter.

Bright Viewing

Since much existing-light photography is done in relatively dim conditions, a viewfinder that presents you with an easy-to-see viewing/focusing image will help you compose and focus accurately. Any vital information about camera functions displayed in the finder should be easy to see, too. If you're using a single-lens reflex camera, a high-speed lens with a maximum lens opening of $f/2$ or larger will make the image on the viewfinder screen brighter.

Accurate Focusing

The focusing device should be sufficiently large and bright to permit easy use in dark areas. Although you can use fixed-focus cameras and camera models that require estimating subject distance, subjects at close and medium distances in dim light require accurate focusing for sharp pictures. Automatic focusing systems built into some cameras or into some interchangeable lenses for single-lens reflex (SLR) cameras may not function reliably in very low light levels. If you have an autofocus camera or lens, check the owner's manual to see if the system is suited for use in fairly dark surroundings. If it isn't, focus manually if you can with your equipment.

Here again a high-speed lens on an SLR camera is a big plus. Depth of field is very shallow as you focus with the lens at its maximum aperture; this makes it easier to judge when your subject is in critically sharp focus.

Sensitive Exposure Meter

A sensitive built-in exposure meter, or light meter, or a separate hand-held meter that reads accurately in dim light will increase your yield of well-exposed pic-

graphs can withstand considerable enlargement or projection on a screen to a very large size.

The journalistic approach is the method of choice for capturing fluid situations in which you need to follow or stop motion, as in candid or action photography. This is the method to use when you want to take many pictures from many different points of view in a short period, and you don't have the time or space to use a camera support. The traditional method is the one to use for relatively static scenes when maximum image quality takes precedence over concern with photographing candid situations or stopping motion. The traditional technique may be the method to choose for situations when you have more time to set up your camera on a camera support and make careful observations and adjustments for best framing and composition. You will find examples later in this book in which elements of *both* shooting styles are combined to meet specific picture requirements. Existing-light photography is very much an art of compromise.

tures. A hand-held exposure meter is especially helpful if your in-camera meter is not sensitive enough to give a reliable reading in dim lighting or is not working properly, or if your camera does not have a built-in light meter. For scenes too dim, too complex, or too inaccessible to permit making useful exposure readings with a meter, you can use the tables of suggested existing-light exposures in the following chapters.

Adjustable shutter speeds you can set directly by turning a shutter-speed dial or indirectly through other camera controls enhance your ability to hand-hold your camera and still obtain proper exposure. This also helps you photograph motion in many situations. For dim-light shooting, it's helpful if the shutter provides a range of timed speeds down to 1 second or longer and a B setting for time exposures with a camera support.

Adjusting the lens aperture increases or decreases the amount of light the lens transmits to the film during any given period of time. Apertures of f/2.8 and larger are desirable for existing-light photography in dim surroundings. Large apertures let you use shutter speeds fast enough for hand-holding your camera.

Adjustable Shutter and Lens

Adjustable shutter speeds and *f*-stops, whether set by you or by the camera, increase your ability to deal with existing-light situations. If you have a camera with automatic exposure control, it's handy to be able to override the automatic system or make settings manually in lighting that might fool the camera. If you anticipate photographing often in very low light, a shutter that provides timed speeds down to 1 second and a B setting for longer exposures increases your options.

Tripod Socket

A tripod socket in the camera body lets you mount the camera on a tripod or other support with a screw-type fitting when you take pictures at shutter speeds too slow for hand-held photography. If your camera doesn't have a tripod socket, you can improvise ways to brace it during long exposures (see "Camera-Handling Techniques," page 20.)

LENSES

In terms of existing-light use, the most important attribute of a lens is its light-gathering ability. A lens with a reasonably large maximum aperture, such as *f*/2.8 or larger, will let you work at faster shutter speeds in dim light than one with a smaller maximum aperture. With high-speed film in your camera, you will be able to take more pictures with the camera hand-held. The higher shutter speeds will also contribute to greater picture sharpness by minimizing subject and/or camera movement. Most modern 35 mm and other hand-held cameras are equipped with or may be fitted with normal-focal-length lenses of *f*/2.8 or larger maximum aperture. Much faster normal-focal-length lenses, with apertures ranging between *f*/2 and *f*/1.2, are available for most interchangeable-lens 35 mm cameras.

Generally, you can hand-hold your camera to photograph most existing-light subjects if your camera has an *f*/2.8 or faster lens and you're using 1000-speed film, or if your camera has an *f*/2 or faster lens and you're using 400-speed film. These guidelines assume that a recommended shutter speed of 1/30 second is the slowest exposure time you will use to hand-hold your camera with a normal-focal-length lens. See "Stopping Camera Motion" on page 22 and the exposure table on pages 42 and 43.

If you have an interchangeable-lens camera with several lenses, select the fastest one for existing-light use, particularly if the camera is a single-lens reflex. Shutter-speed considerations aside, the brighter view through a larger aperture will make focusing and composing much easier in dim surroundings.

Wide-Angle Lenses

Wide-angle lenses, which include more of a scene at a given distance than a normal-focal-length lens, are helpful when you

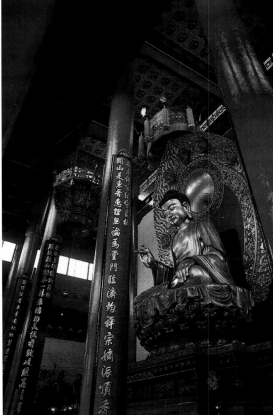

Norm Kerr

Since a wide-angle lens lets you record more of the scene without moving farther from the subject, it is very useful in confined interiors. Here a wide-angle lens expanded a setting optically to show the statue relative to its surroundings.

shoot in confined areas indoors or when you want to capture a broad view of the outdoor world. A distinct bonus of wide-angle lenses is that they minimize the effects of minor camera movement, allowing you to make sharp pictures with a hand-held camera at lower-than-usual shutter speeds. A wide-angle lens also offers more depth of field than a longer-focal-length lens at the same camera-to-subject distance and the same lens opening.

A wide-angle lens is good to use when you want to shoot fast and you don't have time to adjust the focus with the camera focusing aid or rangefinder. Since a wide-angle lens is less critical for focus than longer-focal-length lenses, you can just estimate the subject distance quickly and set the lens focusing scale. These lenses are so forgiving that with practice, you may be able to make candid shots of unposed expressions without looking through the viewfinder and alerting your subjects.

A telephoto lens lets you make a larger image on film without moving closer, bridging the distance optically. Hold cameras with telephoto lenses steady because they magnify camera motion along with the image. Also, pay particular attention to focusing accurately because depth of field is shallow with these lenses.

Norm Kerr

Here, a 35-105 mm focal-length zoom lens on a 35 mm camera was used at 35 mm wide-angle (top), 50 mm normal (center), and 105 mm telephoto (bottom) settings from a fixed distance. To obtain sharp pictures and avoid the blurred effects of camera motion with a zoom lens at telephoto settings on a hand-held camera, you should use high shutter speeds. At the 35 mm wide-angle position, you could use 1/30 second, but at the 105 mm telephoto position, you would need to use 1/125 second for hand-holding your camera.

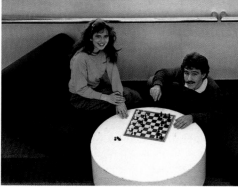

Tom Beelmann

Telephoto Lenses

Telephoto lenses help you approach and isolate your subject without actually moving closer by projecting a larger image on the film. In so doing, they also magnify camera movement and require extra-steady holding and the use of higher-than-normal shutter speeds for best sharpness.

Generally, because existing light is characterized by low light levels, the use of telephoto lenses with a hand-held camera is limited to some extent. Exposures for most existing-light pictures require large lens openings and relatively slow shutter speeds. Many telephoto lenses and zoom lenses have smaller maximum apertures than normal-focal-length lenses, and require higher shutter speeds for hand-held photography. For these reasons, the use of a telephoto lens is limited to focal lengths of about 150 mm or less with a hand-held camera. A camera support is necessary for telephoto lenses of longer focal length or whenever the light is too dim to permit a high enough shutter speed to use the camera hand-held. See page 22.

When you use a telephoto lens, depth of field will be shallower than if you used a lens of shorter focal length at the same camera-to-subject distance and f-stop. If good depth of field is required for your subject, don't use a telephoto lens hand-held. Focusing is more critical with a telephoto lens because of the shallow depth of field, so focus carefully.

Zoom Lenses

A zoom lens is very convenient because it lets you change image size on the film continuously over a range without changing your distance from the subject and without physically changing lenses. This range may extend from wide angle to telephoto. Many zoom lenses have maximum apertures smaller than $f/2.8$ and are therefore not well suited to hand-held photography in low light. You may be able to use zoom lenses effectively, though, under brighter light levels or when you can use a tripod or other firm camera support. Some zoom lenses have, in effect, more than one maximum aperture. At the short end of the focal-length range, the maximum aperture may be $f/2.8$, for example; then it reduces gradually to $f/3.5$ or smaller as you shift the focal length toward the long end of the range.

If you're using a zoom lens with a hand-held camera in dim light and must use a slow shutter speed, try to stay with the shorter focal-length settings. If you're using the telephoto setting, be sure that your shutter speed is high enough to obtain a sharp picture. See page 22. It's a common pitfall to overlook this condition with an aperture-preferred automatic camera, which determines the shutter speed depending on the lens opening you select. It's very easy to forget to check whether the shutter speed the camera selects is high enough for hand-holding your camera with a zoom lens set on telephoto. The slower shutter speeds may be adequate for the shorter-focal-length settings of the zoom lens, but not for the longer-focal-length settings.

USEFUL ACCESSORIES

Most of the time, a suitable camera, lens, and film are all you need to make satisfactory existing-light pictures. Every now and then, though, having the right accessory can make the difference between getting the picture you want and having to settle for something less. The following accessories are basic aids to good existing-light photography.

Tripods

When the light is too low to make sharp pictures without camera motion with a hand-held camera, use a tripod if conditions permit. Mounting your camera on a tripod when you have to use slow shutter speeds or time exposures helps you make the sharpest possible pictures within the limitations of the exposure times you're using relative to any subject motion.

Tripods come in all sizes from pocketable mini models to comparatively huge heavyweights. Carrying a small tabletop tripod in your equipment bag is a form of low-light insurance. These small, compact tripods are fast and easy to use. You can press the base against a wall, table-top, or similar surface, or even your chest to help steady your camera. The mini tripods are usually faster to use and easier to carry but may not be as steady as the larger, heavier tripods. Full-size models provide maximum versatility and stability when size and weight are not important.

When you can foresee the need for a tripod, take a full-size model with you for increased steadiness. Since the main reason for using a tripod of any size is to support and hold the camera, look for a tripod that has rigidity and stability as well as portability.

Camera Clamps

A camera clamp screw-mounts to the camera's tripod socket and lets you position the camera firmly by locking the jaws on any strong, immobile object that's the right size and in the right place. Depending on the clamp jaws, you may be able to mount your camera on a car door or window, on a fence rail, or on the back of a chair. Take care that the jaws don't mar objects of value.

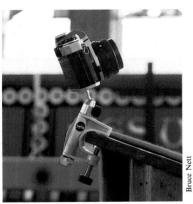

A camera clamp can provide firm support in places where tripods are prohibited or cannot be used for reasons of convenience or safety.

Bean Bags and Shot Bags

Small bean bags and canvas bags filled with fine lead birdshot can be good improvised camera props when more rigid supports are unavailable or cannot be used. Work your camera gently against the bag until it nestles in a form-fitting depression; then squeeze the bag to adjust the camera position when you refine composition. If you don't have a bean bag with you, you can use a folded jacket, a soft hat that you can crumple, a soft camera bag, or a book to rest your camera on for picture-taking.

Bruce Nett

A bean bag or small bag filled with fine lead shot makes a formfitting prop for your camera during long exposures. Squeeze or poke the bag gently to make small changes in camera position. Or you can improvise and use a crumpled-up jacket or soft hat for the same purpose. Here a bean bag is supported by a post.

Cable Release

A cable release lets you trip the shutter of your camera when it's on a tripod or other type of support without risking camera movement from the touch of your finger. A supple cable release about 12 inches (30 cm) long or longer can sag limply or form a rainbow curve between hand and camera. This helps prevent the movement of your hand jiggling the camera.

A locking-type cable release is beneficial for making time exposures when you're using the "B" shutter setting on your camera. This will keep the shutter

open on B until you release the lock. Some cameras have a "T," or TIME, setting which opens the shutter when you push the release button and holds it open until you push the release a second time. Keep a cable release in your equipment bag and another with your tripod, perhaps taped to one of the legs. That way you'll be sure to have one when you need it. Instead of using a cable release, you can let the camera self-timer make the exposure.

Small Flash Unit

Although the essence of existing-light photography is making pictures by the natural lighting on the scene, it's sometimes desirable to lighten shadows that would otherwise record too dark in contrasty lighting. This is not true existing-light photography, but the pictures appear very similar to those that are made by existing light. A small, relatively low-power electronic flash unit or a unit that has a light-output-reduction switch will let you lighten the shadows easily. Many SLR and most non-SLR cameras have a built-in flash unit that you can use for nearby subjects. The technique for using fill flash is described in the chapter "Existing-Light Pictures at Home."

Pocket Flashlight

Tuck a pocket flashlight in your pocket, purse, or camera bag when you go in search of existing-light subjects. It will help you see what you're doing when the ambient light is too dim for reading shutter speeds, *f*-stops, and exposure guides. It will also help you find anything you drop in the dark.

Spare Batteries

Modern photographic equipment lives on batteries. Keep a spare set of batteries for all your battery-powered photo equipment. Take spares with you, even if your picture outing is just for a few hours and within walking distance of home. Then you won't be caught short by unanticipated battery failure. If you're using rechargeable batteries, make sure they are adequately charged. It seems that batteries never fail when replacements are readily available.

Lens-Cleaning Materials

Clean lenses make sharper images than dirty ones, particularly in existing-light conditions. Check your lenses regularly to make sure exposed glass surfaces are free of dust and fingerprints. A soft, clean lens brush removes dust safely. Stubborn specks and fingerprints can be removed with KODAK Lens Cleaner and Lens Cleaning Paper. Don't use chemically treated eyeglass-cleaning tissues, because they are not designed for cleaning camera lenses and may remove the anti-reflection coating on the outer surface of the lens.

Lens Shades

Although lens shades are not a necessity for most existing-light pictures, they are useful in two different ways. They shield the lens from strong light outside the picture field, reducing internal lens reflections, and promoting sharper, more sparkling pictures. And they provide some physical protection for the front surface of the lens against dust, dirt, and contact with foreign objects. If you have several lenses and lens shades, be sure to use the right shade for each lens. A shallow lens shade intended for a wide-angle lens provides insufficient shielding for a normal or telephoto lens. A deeper, narrower shade made for a telephoto will vignette, or cut off, the corners and sometimes the edges of the picture if you use it on a wide-angle lens.

Properly designed lens shades can keep stray light from degrading image quality and also offer some physical protection to the lens surface. Match the right shade with the right lens if you own several.

Pocket Notebook and Pencil

The best way to ensure repeating successful results and to avoid repeating mistakes when you refine a new technique or photograph in difficult or unfamiliar conditions is to take notes as you take pictures. Keep a small notebook and pen or pencil with your photo gear for recording pertinent data, such as subject, type of film you used, exposure settings the meter recommended, and what you actually did. And by all means write down when and where you take pictures while traveling. That way you'll know whether the dancers in the café were celebrating in Rome, Italy or Rome, New York.

FILMS FOR EXISTING-LIGHT PHOTOGRAPHY

Kodak supplies an extraordinary variety of films for general photography. You can use nearly all of them for existing-light photography, depending on the kinds of photos you want, your taste, and the specific picture-taking circumstances. For example, if you can use a tripod to steady your camera and use slow shutter speeds, a slower-speed film may do a fine job for existing-light photography.

Generally, the films are grouped according to the kind of pictures they make—color or black-and-white, prints or slides. Kinds of film can also be categorized broadly according to their sensitivity to light—film speed—and to their color balance.

Sensitivity to Light

A film that is highly sensitive to light, commonly called a high-speed or fast film, requires comparatively little exposure to light to form a useful image. Films that are relatively less sensitive to light, generally referred to as medium-speed and low-speed films, require correspondingly greater exposure to light to form useful images.

In bright, conventional light—outdoors in the daytime—low- and medium-speed general-purpose films are fast enough for photographing active subjects with a hand-held camera. In progressively dimmer light, such as existing light, high-speed films continue to let you hand-hold the camera while capturing motion sharply on film. The fast films offer increased depth of field with smaller lens openings as well as the opportunity to shoot existing-light action at higher shutter speeds.

Since most people prefer the freedom of hand-holding their camera to take pictures in a variety of lighting conditions, high-speed films are the mainstay for existing-light photography. However, you can use medium- and low-speed films if the existing light is relatively bright and you don't have to stop motion with fast shutter speeds, or if you steady the camera with a tripod or an improvised support and use slow shutter speeds or time exposures in dim existing light.

Mike Occhionero

For the picture above, 100-speed film was fast enough to make an informal portrait in bright existing light with a handheld camera. During a circus act, however, the photographer needed the extra speed of a 400-speed film, with push processing, ISO 800, to make a handheld action-stopping shot. M & M Circus International.

Film Speeds

Film sensitivity is determined by the manufacturer according to standard procedures. In the United States and some other parts of the world, film sensitivity is expressed in terms of ISO (formerly ASA) arithmetic speed numbers. The higher the film-speed number, the greater the sensitivity of the film. For example, a film rated at a speed of ISO 1000 is two and a half times as sensitive as one rated at ISO 400, and ten times as sensitive as a film rated at ISO 100. Be sure to set the film-speed dial on your camera or your hand-held exposure meter to the correct speed number for the film you are using. This is unnecessary with some 35 mm cameras that automatically sense the speed of the film with DX encoding, and for 110, 126, and disc cameras. For more on DX encoding, see page 46.

Some film manufacturers outside the United Sates express film sensitivity in ISO° (formerly DIN) logarithmic numbers. Kodak provides both ISO/ISO° film-speed numbers on the outside of film cartons and in some film instructions in the form, "ISO 1000/31°," for example. The 1000 is the ASA arithmetic equivalent and 31° is the DIN logarithmic equivalent. Note that the ISO° logarithmic speed number has a degree symbol (°) after the number to help identify it.

The relationship between ISO arithmetic and ISO° logarithmic film speeds are shown in the table on the next page. Since the primary film-speed system in the U.S.A. is the ISO arithmetic system,

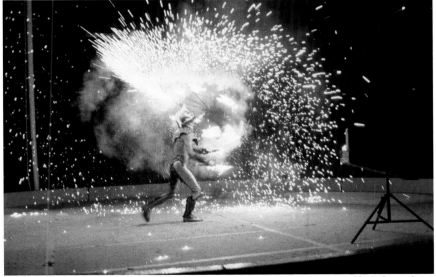

Martin Czamanske

Ed Austin

In bright existing light, you can use a medium-speed film for hand-held photography if you don't need a great deal of action-stopping capability or depth of field.

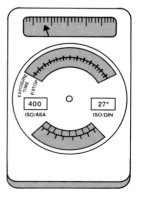

If your exposure meter has film-speed scales for both ISO (ASA) and ISO° (DIN) speed numbers, be sure to set the right number on the right scale. Otherwise, considerable exposure error can result.

ISO (ASA)/ISO° (DIN) FILM SPEEDS

ISO (ASA)	ISO° (DIN)	ISO (ASA)	ISO° (DIN)
6	9°	160	23°
8	10°	200	24°
10	11°	250	25°
12	12°	320	26°
16	13°	400	27°
20	14°	500	28°
25	15°	640	29°
32	16°	800	30°
40	17°	1000	31°
50	18°	1250	32°
64	19°	1600	33°
80	20°	2000	34°
100	21°	2500	35°
125	22°	3200	36°

ISO (ASA) arithmetic film-speed numbers can differ greatly from the equivalent ISO° (DIN) logarithmic film-speed numbers. Note that ISO° (DIN) numbers used in some countries outside the United States are followed by a degree symbol (°). For example, when film speed is given as ISO 400/27°, 400 is the former ASA value and 27 is the former DIN value.

most of the equipment sold in the U.S.A. is designed for use with this system. However, some of this equipment has both speed systems included. If your in-camera meter or separate exposure meter has film-speed scales for both speed systems, be sure to set the applicable film-speed number on the correct scale to avoid serious exposure error.

We use the ISO arithmetic system throughout this book.

Kodak films rated at ISO 800 to 1600 are designated very high-speed and those at ISO 250 to 640 are considered high-speed films. Those rated from ISO 200 down to ISO 64 are medium-speed, and films with still lower speed numbers, ISO 50 and below, are referred to as low-speed films.

Films with ISO speeds of 160 and higher are good choices for existing-light photography because they allow brief exposures even in fairly dim lighting. Very high-speed and high-speed films, from approximately ISO 1600 to 400, will let you photograph almost anything you can see while handholding a camera with a fast lens. Medium-speed films at the upper end of the category, such as from approximately ISO 100 to 200, allow handheld photography in relatively

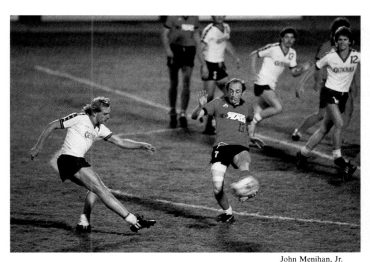

John Menihan, Jr.

Use a very high-speed film to stop action in low light. Exposure was 1/500 second at f/2.8.

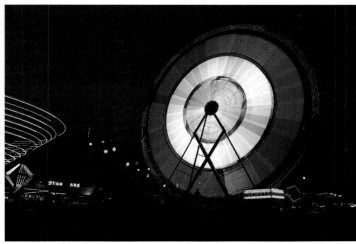

John Phelps

To make this picture, the photographer exposed KODACHROME 64 Film (Daylight), ISO 64, in a tripod-mounted camera using a time exposure. The long exposure let the moving amusement-park ride create a colorful blur, while the sharp, fine-grain film recorded the stationary elements in the scene in detail. An exposure of 2 seconds produced this effect.

bright existing light, but you may need a tripod for best results in dim conditions. Medium-speed films at the lower end of the category and low-speed films, such as 25- and 64-speed films, provide superb picture quality when you can use a tripod and the subject permits using slow shutter speeds or time exposures. You may also be able to use medium- and low-speed films for handheld photography in bright existing-light conditions, such as window light.

As a general rule for existing-light photography with a handheld camera, use the fastest film you can, which will give you the image quality desired for specific situations. There are many valid exceptions to this rule. Examples of the rule and exceptions to it occur frequently throughout this book.

Boosting Film-Speed Numbers

Although the ISO speed of a film accurately represents its sensitivity as determined by standard test procedures, you can make some films behave as if they were substantially more sensitive than the ISO speed indicates. The procedure, called push processing, consists of underexposing the film by a specific amount and then extending development to help compensate for the underexposure. KODAK EKTACHROME Films for color slides and KODAK T-MAX 400 Professional, T-MAX P3200 Professional and TRI-X Pan Films for black-and-white prints respond very well, with qualifications, to moderate pushing under certain conditions. The technique will be covered in greater detail in the chapter "KODAK Films for Existing-Light Photography."

Color Rendition

The first distinction to make among films is whether they produce color or black-and-white pictures.

Black-and-White Films

Since black-and-white films, such as KODAK TRI-X Pan Film, translate the colors in the scene into appropriately

light or dark shades of gray and have good exposure latitude, the films are simple to use for existing-light photography. It doesn't really matter whether the subject is illuminated by standard daylight, bluish skylight, yellow-orange incandescent tungsten lamps, or fluorescent tubes of different color qualities. Colors you remember as light will be rendered as light tones of gray; colors that appeared dark will be rendered as darker tones of gray; and extremely light and dark parts of the scene will be rendered as white and black, respectively.

The ability of black-and-white films to produce plausible-looking, although monochromatic pictures, in virtually any common type of lighting makes them very well suited to existing-light photography. No matter what sort of lights or odd combinations of lights illuminate a scene, you can usually photograph freely in black-and-white without having to do anything special to get realistic gray-tone rendition. Also, great opportunity for contrast control exists in the black-and-white printing process, which allows making satisfactory prints from negatives of high-contrast or low-contrast subject matter.

Jamey Stillings

Generally, a good film to use for hand-held existing-light photography is one with a high film speed combined with excellent graininess and sharpness qualities. KODAK T-MAX 400 Professional Film is an excellent choice when you want black-and-white prints.

Black-and-white films have great potential to produce dramatic, artistic renditions with a rich range of black-and-white tones. Even though black-and-white photographs cannot be true representations of the scenes' natural color, we readily accept black-and-white photos because we are so accustomed to seeing them. Pictures from the early days of photography are mostly black-and-white, and many photographers still choose black-and-white as the medium for expressing their creative talents in the art of photography.

Color Films

The other principal class of films consists of those that produce finished pictures in color. Two further major subdivisions are films that produce color negatives intended primarily for making color prints and films that are processed into positive color slides, or transparencies. Color films capture the color of the light illuminating the scene. The sometimes subtle differences in the color of the illumination, while usually of no significance with black-and-white film, are important with color film. Color films exaggerate the color differences between light sources

There are important differences between the way color films perform, especially for existing-light photography. Color-negative film has more exposure latitude and more tolerance for color differences of light sources because corrections can be made during the printing process. Color-slide film is more critical for both exposure and matching the color of the light source to the color balance of the film, because the processed film you get back as a color slide is the film that you exposed in your camera. Here 1000-speed Kodak film has handled the combination of tungsten lighting and the faint glow of daylight in the sky at dusk very well.

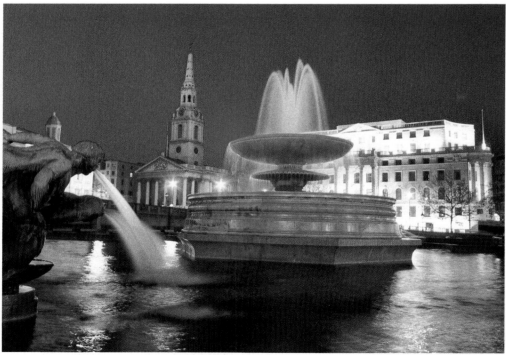

Bruce Nett

used for general illumination. This happens because our eyes are more forgiving when we view the scenes directly and we tend to minimize variations in color quality of the illumination from one scene to another.

Color Negative Films Are Versatile

To a remarkable extent, color negative films are universal films. They are capable of providing good color reproduction under most common existing-light situations and rendering scene colors well under more difficult lighting conditions when color rendition in your photographs is not critical. This is primarily because color balance can be corrected during printing. The printing stage also permits some contrast control through choice of printing paper. These qualities make color negative films very useful in existing-light photography. Whether your intent is to reproduce the scene as closely as possible or to interpret it as fancifully as you can, a single negative and careful printing can carry you from the real to the surreal.

Color-Slide Films Should Match the Light Source

To obtain realistic color rendition with color-slide materials, such as KODAK EKTACHROME and KODACHROME Films, match the color balance of the film with the appropriate light source. Or you can use a color filter to adjust the quality of the light entering the camera lens if there's sufficient light and correct color rendition is important. Color-slide films are balanced for use with daylight or various types of tungsten, or incandescent, illumination. Daylight color-slide films produce strong yellow-orange results when exposed under tungsten lighting without the proper correction filter. Tungsten color-slide films, which are balanced to produce realistic color rendition with tungsten illumination, produce excessively blue pictures when exposed in daylight or with electronic flash, which is similar to daylight in color quality. Since

the film you expose in the camera becomes the finished color slide after processing, there is no intermediate stage during which extensive color corrections or deliberate deviations may be made.

Although it's best to match film and light source for optimum color rendition, existing light seldom matches exactly the standard light sources for which color-slide films are balanced. Often several different, and theoretically incompatible, light sources illuminate the same area simultaneously. That shouldn't be cause for despair or discourage you from using color-slide films when you need slides rather than prints. The object of most existing-light photographs is to evoke the natural appearance of the scene, not necessarily to reproduce it literally, tone for tone and color for color.

FILTERS

For most of existing-light photography, it's impractical to use filters because of the diversity of light sources and the loss of light absorbed by the filter. This loss often makes it difficult to use a hand-held camera because longer exposure times are needed. Light sources of different color quality in the same scene further complicate the use of filters. The realism of the existing lighting usually compensates to a large extent for color rendition that may be less than ideal.

This book does include filter information for use when critical color rendition is important for your picture requirements, and you are willing to accept the loss of light absorbed by the filter and the restrictions this imposes on your picture-taking techniques.

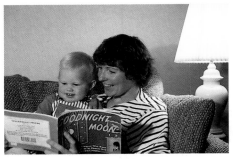
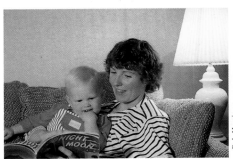

Color slide films intended for use with tungsten incandescent lamps produce realistic, natural-looking color rendition with a variety of incandescent light sources, including household lamps (top). Under the same conditions, daylight color slide films will yield transparencies with a pronounced yellow-orange cast.

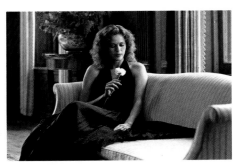
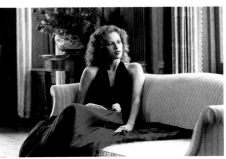

When daylight is the dominant light source, a daylight color slide film produces natural-looking color rendition (top). Exposing an artificial-light color slide film to daylight results in a picture with a cold, bluish cast.

Bob Harris

Tom Beelmann

Camera-Handling Techniques

HOW TO MAKE SHARPER PICTURES IN LOW LIGHT

Since most existing-light photography takes place in lower light levels than are usually encountered in everyday outdoor shooting in the daytime, shutter speeds are generally slower than normal. And often you will use wider lens apertures than usual to make the most of minimal lighting. As a result, existing-light photography places greater demands on your ability to hold the camera steady, focus accurately, and generally employ the tools and techniques of photography. In fact, though, you don't have to learn anything new and exotic. The following hints for making sharper pictures in low light simply mean that you should pay slightly more attention to the techniques you already use in general picture-taking.

Learning how to hold your camera steady lets you take sharp pictures with a hand-held camera at the relatively slow shutter speeds often needed to obtain enough exposure in existing light. Photographed through a multi-image lens attachment at 1/30 second f/4 on KODAK EKTACHROME 160 Film (Tungsten).

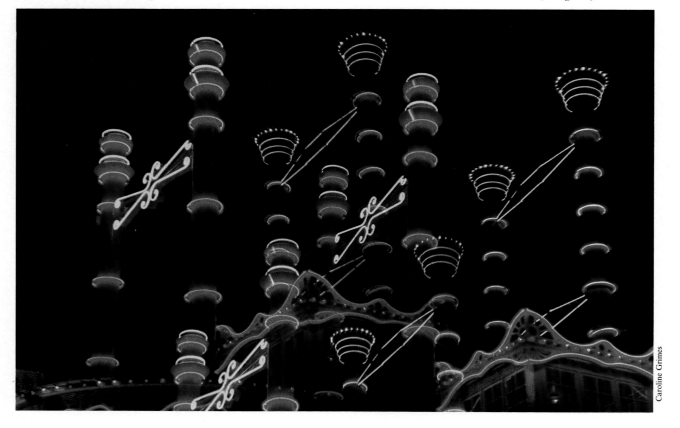

Caroline Grimes

CAMERA STEADINESS

Take a Steady Stance

Holding a camera steady begins at ground level. Stand with your feet about 18 inches (0.5 m) apart and your weight evenly distributed for a steady stance. Stand comfortably erect and bring the camera viewfinder to your eye. Don't duck or slouch to meet it partway. Keep your elbows tucked in as close to your body as possible for additional steadiness. Pressing the camera lightly against your face helps, too, but don't overdo it. If you press too hard, you may induce tremors from tension and fatigue and your arms will be shaky.

With normal-focal-length or wide-angle lenses, many people find that their grip is steadier when they hold the camera body on both sides with their fingers on the front and thumbs on the back. If your camera is equipped with a telephoto or zoom lens that is significantly longer and/or heavier than a normal lens, use your left hand to support the lens rather than holding the camera body. This conveniently positions your left hand for adjusting the focus and/or zoom control on the lens.

Some photographers prefer to use a similar method for short, light lenses, too. Rest the base of the camera body on the heel of your hand and grasp the lens focusing collar with your fingers. Try both camera-holding methods with short, light lenses and choose the one that you find steadier and more convenient to use. To determine how steady you're holding your camera, perform the camera-holding test described on page 22.

Brace Yourself

Unfortunately, people do not make good camera supports when they need to use slow shutter speeds. However, you can gain steadiness by taking advantage of your surroundings. Lean against a pillar or wall, rest the base of the camera on the back of a chair, a railing, or the hood of a car, or prop your elbows on a table. You may feel conspicuous doing so at first, but the sharper pictures you make will dispel your self-consciousness.

Release the Shutter Gently

Use a light touch on the shutter release to avoid jarring the camera at the moment of exposure. For the smoothest release, increase pressure on the button gently and steadily until the shutter trips. Another way to release the shutter with even less chance of moving the camera is to use the self-timer and let the camera actuate the shutter. This lets you concentrate on holding the camera steady while the self-timer makes the exposure for you.

Set the self-timer for a shorter-than-normal interval so that you don't have to wait for an excessively long time for the shutter to trip. This self-timer technique is most beneficial when you photograph stationary objects or use shutter speeds that are borderline for being fast enough for hand-holding your camera.

When you use a short, light lens, you can hold your camera steady by grasping the camera body on both sides with your hands. With long, heavier lenses, position your left hand under the lens to support its weight.

Bob Harris

For extra steadiness at slow shutter speeds, brace yourself against or rest the camera on any firm support you can find.

You'll be able to hold your camera steady if you keep your elbows tucked in close to your body and stand with your feet somewhat apart.

Hold Your Breath

Proper breath control is as important to the existing-light photographer as it is to the Olympic sharpshooter. Just before releasing the shutter, take a deep breath, exhale until you feel comfortable, and then hold your breath until you've tripped the shutter. You don't want your lungs expanding or contracting to cause body and camera motion during the exposure.

Check Your Steadiness

You can practice hand-holding your camera and check on your progress without actually exposing any film. Tape a small mirror to your camera at about a 45° angle to the lens axis, as shown in the illustration below. Set up a flashlight or slide projector in a slightly darkened room to shine from one side toward the mirror while you're holding the camera in shooting position. The mirror will reflect the light beam toward the wall at which you aim the lens. Observe the patch of light as you release the shutter. The less movement you see, the more steadily you are holding your camera.

USING MOTION-STOPPING SHUTTER SPEEDS

If the camera, the subject, or both should move during a relatively long exposure, the film will record a blurred image. To record a sharp, clear image, you need a shutter speed fast enough to freeze such motion. Shutter-priority automatic cameras pose no problem with this because you select the shutter speed and the camera selects the lens opening. With an aperture-priority camera, you select the lens opening and the camera selects the shutter speed. You can make an aperture-priority camera select a high shutter speed by choosing a large lens opening. Monitor the camera's exposure readouts to be sure.

The only way to make many programmed automatic cameras that set both the shutter speed and the lens opening to use a relatively high shutter speed in low light is to use fast film. Some programmed cameras let you switch to a special exposure program that selects higher shutter speeds than the normal program. Refer to your camera manual for the specific features and instructions for your camera.

STOPPING CAMERA MOTION

There is a useful rule of thumb for estimating the slowest shutter speed you can use successfully in hand-held photography. Place the number 1 above the focal length of the camera lens expressed in millimetres; the resulting fraction is approximately the slowest shutter speed to use with that lens when you are hand-holding the camera. For example, with a 35 mm wide-angle lens, the equivalent shutter speed would be 1/35 second. In fact, 1/30 second is the closest marked shutter speed found on modern cameras, and that would be the base shutter speed with that lens.

Slowest Shutter Speed for Hand-holding a Camera in Average Conditions =

$$\frac{1}{\text{Lens Focal Length in Millimetres}} \text{ Second}$$

People differ in their ability to hold a camera steady, and a particular person's ability can change quite a bit from time to time. When you are well rested and calm, you may be able to hand-hold a camera at somewhat slower shutter speeds than the formula suggests. When you are tired, have run up several flights of stairs, and are being buffeted by a stiff breeze, you need to use considerably faster shutter speeds. Bear in mind, too, that the formula does not take into account stopping subject motion; nor does it allow for the beneficial effects of bracing yourself or the camera.

Many photographers find that they can also obtain satisfactory results at 1/30 second with a normal-focal-length lens. However, it's best to use faster than the slowest recommended shutter speeds for hand-holding whenever conditions permit and you don't need a small lens opening for greater depth of field.

Be especially careful to use high enough shutter speeds with telephoto lenses and zoom lenses at telephoto settings. These lenses magnify the effects of camera motion as well as the image of the subject. They are also usually longer, larger, and heavier than normal-focal-length and wide-angle lenses. This makes a more unwieldy camera-lens combination, which is harder to hold steady. Use a shutter speed *at least* as high as the rule states or a shutter speed one or more steps higher when possible.

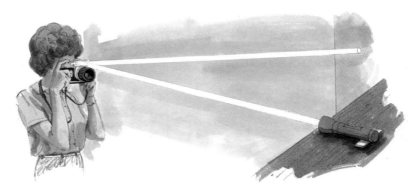

You can test your ability to hold a camera steady by shining a beam of light in a darkened room at a small mirror taped to your camera at about 45° to the lens axis. If the patch of light the mirror *reflects moves noticeably when you trip the shutter, keep practicing to develop a gentler touch on the shutter release and a steadier camera-holding technique.*

John Menihan, Jr.

To capture sharp images of active subjects, select shutter speeds fast enough to stop the action. Very high-speed films are the most practical choices for photographing moving subjects.

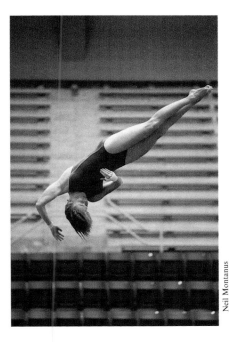

Neil Montanus

If you cannot use as high a shutter speed as necessary to stop the action, wait to take the picture until a peak in the action occurs. Here the photographer waited until the diver was at the peak of her dive before making the exposure at 1/125 second.

STOPPING SUBJECT MOTION

With active subjects, use the highest shutter speeds you can to stop motion in your pictures. To do so in any but the brightest existing-light situations requires the use of high-speed films and large lens apertures. The table on the next page indicates shutter speeds recommended to stop various types of motion at different distances from the camera and from different directions of travel relative to the lens axis and film plane.

Quite often, existing light will not be bright enough for you to use as high a shutter speed as you would like. There are two basic and opposite ways to stop action in photos other than using a high shutter speed. The first is to wait until there is a lull in the action or a peak moment when the subject appears suspended or slowed for an instant. You can then stop the action with a slower shutter speed. The other approach is to pan the camera with the moving subject.

23

SHUTTER SPEEDS FOR STOPPING ACTION For Normal-Focal-Length Lenses

| Speed of Subject Motion | | Moving Subject | Distance from Camera | | Direction of Subject Motion | | |
Miles Per Hour	Kilometres Per Hour		Feet	Metres	← OR →	↖ ↗ OR ↙ ↘	↑ OR ↓
					Shutter Speed in Seconds		
5	8	**Slow Action**—People walking, children playing with moderate motion, babies not holding still	12 25 50 100	4 8 15 30	1/500 1/250 1/125 1/60	1/250 1/125 1/60 1/30	1/125 1/60 1/30 1/15
10	16	**Moderately Fast Action**—Children running; horses moving at a moderate pace; baseball, football, soccer, and hockey players moving at a medium pace; boxers, wrestlers, gymnasts, bowlers, parades, slow-moving vehicles, amusement park rides, performers, skaters, swimmers	12 25 50 100	4 8 15 30	1/1000 1/500 1/250 1/125	1/500 1/250 1/125 1/60	1/250 1/125 1/60 1/30
25	40	**Fast Action**—Fast runners, running horses, divers; basketball, baseball, football, soccer, and hockey players moving at a fast pace; fast-moving skaters; moving cars in traffic	12 25 50 100	4 8 15 30	1/2000 1/1000 1/500 1/250	1/1000 1/500 1/250 1/125	1/500 1/250 1/125 1/60
50	80	**Very Fast Action**—Race cars, motorcycles, race horses; field and track events with rapid motion; tennis players	25 50 100 200	8 15 30 61	1/2000 1/1000 1/500 1/250	1/1000 1/500 1/250 1/125	1/500 1/250 1/125 1/60

Note: You can estimate in-between values in the table.

This table indicates shutter speeds that will stop the action of various moving subjects sharply with a normal focal-length lens. With a wide-angle lens of about half the focal length of the normal lens, you can use the next slower shutter speed. With a telephoto lens of about double the focal length of the normal lens, use the next faster shutter speed.

Sports photographers often pan the camera to record fast-moving subjects at slower-than-optimum shutter speeds. Here, panning during an exposure of 1/30 second at f/4 made the moving subject appear sharp as it blurred the background, giving the photograph a look of action and speed.

Panning

Panning means tracking the moving subject by swinging the camera smoothly to keep the subject in a particular spot in the viewfinder and continuing to follow the subject as you make the exposure. Panning lets you make sharp pictures of rapidly moving subjects at surprisingly slow shutter speeds, and is much practiced by sports photographers. Stationary objects included in the scene or subjects moving opposite the direction of camera motion will be blurred, adding to the impression of speed. The most important thing to remember in panning is to keep the camera moving with the subject throughout the exposure. Follow through briefly with the panning motion even after you hear the shutter click.

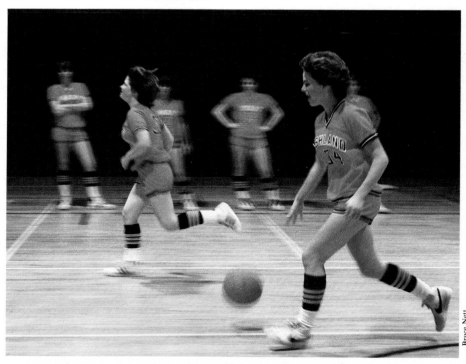

Bruce Nett

DEPTH OF FIELD

Depth of field refers to the zone of apparent sharpness that extends ahead of and behind the subject plane on which you have focused. The greater the depth of field, the more objects in the field of view from near to far will appear to be sharp on film. The more limited the depth of field, the fewer objects outside the plane of exact focus will appear to be sharp. Depth of field is governed by three factors: lens aperture, distance from the subject, and focal length of the lens. When the subject distance remains unchanged, depth of field and image size are controlled by the aperture and the focal length of the camera lens.

When other factors remain constant, the smaller the lens aperture, the more depth of field you obtain. In a given situation, a very wide aperture such as $f/1.4$ or $f/2$ yields minimal depth of field; a small aperture such as $f/11$ or $f/16$ produces much greater depth of field.

For any given lens aperture, depth of field increases as the image size on the film decreases and depth of field decreases as image size increases. The image size becomes smaller when you use a shorter-focal-length lens and/or move farther from the subject. Image size becomes larger when you use a longer-focal-length lens and/or move closer to the subject.

With a specific focal-length lens set to a given aperture, the closer the focusing distance the less the depth of field and the greater the focusing distance the greater the depth of field.

When the aperture and subject distance remain constant, depth of field increases as focal length of the lens decreases, and depth of field decreases as the focal length increases. For example, if you are photographing with a wide-angle-to-telephoto zoom lens with the aperture set to $f/4$ at a fixed distance from the subject, changing the zoom setting to change the image size and focal length will also change the depth of field. At wide-angle settings, which produce small image size, depth of field will be comparatively great. At longer focal lengths at the same subject distance, which yield larger image sizes on film, depth of field will decrease noticeably.

Both pictures were made with the same camera and lens at the same distance from the subject. In the picture above, made at $f/2$, only the subject is sharp. The shallow depth of field rendered foreground and background details as blurs. The picture at the right was made with the aperture set to $f/11$. The greater depth of field obtained at the smaller aperture rendered foreground and background areas more sharply.

Tom Beelmann

The same camera and lens were used to make both of these pictures, with the lens set at $f/5.6$ for both photos. In the picture made at close range, there is little depth of field despite the moderate aperture. Increasing the distance increased the depth of field significantly even though the aperture remained the same.

Tom Beelmann

Both of these photographs were made with the same camera and wide-angle-to-telephoto zoom lens at the same distance. The lens was set at f/4 for both pictures. In the photo made at the 35 mm wide-angle setting, which yields a comparatively small image size on film, more depth of field is evident than in the picture made at the 105 mm telephoto setting, which produces a larger image.

Depth of Field in Low Light

Anytime you need to stop motion without sacrificing depth of field in an existing-light situation, reach for the highest-speed film available. If necessary, consider push processing it an additional stop when possible, which, of course, requires a change in exposure. In low light, when action-stopping and good depth of field are both required, there is simply no substitute for film speed.

When depth of field is important and there is little or no subject motion, use a tripod or other firm camera support. Then you can use slower shutter speeds with smaller lens apertures to obtain the depth of field you need.

If you use an SLR camera that allows previewing depth of field, check the depth of field at the actual shooting aperture. Or, you can refer to the depth-of-field scale on the lens. If there's no depth-of-field scale on your lens, there may be one included in the instruction manual. In many existing-light situations, particularly those with a journalistic flavor, limited depth of field may actually enhance the picture and look more convincing than unexpected sharpness from foreground to background.

When conditions don't allow stopping motion and obtaining great depth of field simultaneously, you will rarely be wrong if you opt to stop motion. A picture in which only the subject appears sharp is preferable to one in which everything but the subject appears sharp or in which nothing at all is sharp.

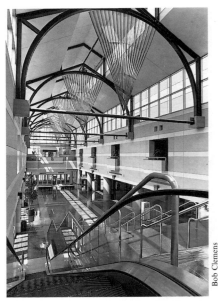

If you need increased depth of field and don't have to worry about subject movement, put your camera on a tripod or other steady support. Then you can use slow shutter speeds with the lens set to smaller apertures. KODAK Technical Pan Film.

Sometimes journalistic or candid subjects look more natural and convincing with limited depth of field. Shallow depth of field often helps rivet the viewer's attention on the subject, softening irrelevant details in the foreground and/or background. KODAK TRI-X Pan Film, 1/60 second f/2, normal-focal-length lens.

FOCUSING CAREFULLY

Because of the limited depth of field associated with the large lens apertures you need for many existing-light situations, focus carefully on the primary subject. At wide apertures, there may not be much margin for error. This is especially important at close shooting distances and with telephoto lenses.

At very close range, you may find it easier to focus by moving the camera nearer to or farther from the subject than by adjusting the focusing ring. Once you've achieved proper focus, be careful to maintain it. Don't bend closer or lean back because even a slight distance change may exceed the available depth of field at a large lens aperture, and the subject may be somewhat soft, or out of focus. And if the subject moves even a little closer to or farther from the camera, refocus.

With zoom lenses you can focus more accurately if you focus with the lens set to the maximum focal length and then adjust the lens to the focal length you want to use for taking the picture. Focusing is most critical at the longest focal length for the lens. You can use this technique only with zoom lenses that do not change focus when the zoom focal-length setting is changed, not with varifocal lenses, which do change focus.

Automatic Focusing

If your camera features automatic focusing, read the owner's manual carefully to determine whether or not you must take any special precautions or follow different procedures in dim light. Some autofocus systems lose efficiency in low light. If that is the case with your camera, or you suspect it might be, override the automatic system or switch it off and focus manually, if possible.

To insure accurate focusing, take care that the autofocus mechanism responds to the principal subject or another scene element at the same distance from the camera. If the autofocus system "reads" a target closer or farther than the subject, it will set the focus for that target rather than for the subject, resulting in incorrect focus for the subject. This can occur easily in busy interiors if the subject is not close enough to dominate the autofocus system. The system will then set the focus for a prominent piece of furniture, a

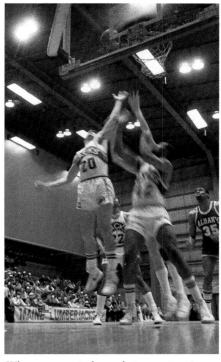

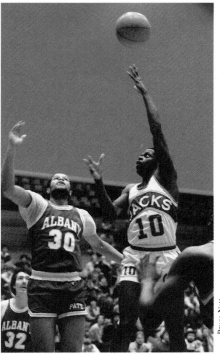

When you must choose between stopping action and obtaining more depth of field, you are safer using the higher shutter speed rather than the smaller aperture. Sacrificing shutter speed to increase depth of field can result in an action picture in which the subjects are not sharp. 1000-speed Kodak film, 1/125 second f/4 (left), 1/500 second f/2 (right).

Bruce Nett

Tom Beelmann

Asymmetrical compositions like this (left, top) often make for more interesting pictures, but can trick autofocus systems into setting the focus for features other than the principal subject. If the main subject is outside the focus area indicated in the viewfinder, focus manually. Or, if the camera has a focus hold, frame the subject in the center while the camera focuses; then lock the focus setting while reframing the scene. See your camera manual.

room divider, or a potted palm. Focus errors can also occur when you compose a picture asymmetrically, with the subject off-center. In conditions that are likely to trick an autofocus system, focus manually if possible. Or if the camera has a focus hold, aim the camera so that the principal subject is centered in the focus area indicated in the viewfinder; then use the focusing lock to hold the focus setting while you reframe the scene for the desired composition.

Some other types of subjects can also mislead an autofocus camera depending on what kind of autofocus system it has. Subjects or objects with low contrast or without a pattern; those objects behind glass; small objects that don't fill the autofocus frame marks in the viewfinder; glossy surfaces; dark surfaces with little detail; subjects without a definite mass, such as flame or smoke; and very bright light sources may cause focusing errors. To determine whether these subjects can fool your autofocus camera, see if the autofocus indicator confirms that the camera is sharply focused and agrees with the actual subject distance. If not, focus your camera manually, if possible, or use the camera-focus hold as described above.

KEEPING YOUR LENSES CLEAN
Clean lenses are a must in existing-light photography because the scenes often include fairly bright lights as main subject elements. So keep your lenses clean to reduce the likelihood of recording flare effects and to prevent image degradation that can be caused by particles of dust and dirt reflecting and refracting light. These detrimental effects can prevent sharp existing-light subjects in pictures.

MAKING LONG EXPOSURES
Sometimes you can create the pictures you want only by making long exposures that do not permit hand-holding your camera. Perhaps you want to maximize depth of field or enjoy the extra-sharp, fine-grain rendition provided by a medium- or low-speed film. Nearly always, long exposures require a tripod or other firm camera support to eliminate camera movement.

Certain types of subjects, like fireworks, need long exposures to record the beauty of the display. Other subjects, such as moving car traffic and amusement-park rides at night, create interesting streaks of light that portray motion when you use long exposure times. These techniques are described more fully in the chapter "Existing-Light Photography in Public Places."

When you use long exposure times, some film characteristics can change. These effects are discussed under "Reciprocity Effects" on pages 54 and 60.

Using a Tripod
Setting up a tripod properly is usually easy. Here are some tips you'll find useful.

For use on a level, flat surface, hold the tripod vertically at the appropriate height with the legs close together and touching the floor. Then adjust and lock the legs for the right length.

Set It Up Level
When you set up the tripod, adjust the length of the individual legs as necessary so that the center column will be vertical and the top of the main section level. On a sloping or irregular surface, you'll need to adjust the legs to different lengths to level the camera. You can make fine adjustments for framing with the tripod ball or pan head.

When the surface is flat and level, you can adjust all three legs to the same length by holding the tripod straight up and down with the legs close together, touching the floor. Loosen the leg locking mechanisms and adjust the length of the legs by holding the tripod at the proper height. Lock one of the legs to the proper length. Then with the tripod vertical, all three legs resting on the floor, and the tripod's weight supported by the leg that's locked, lock the length of the other two legs to the same length as the first one.

Use a Wide Base for Stability
Always spread the tripod legs to a wide, stable position while maintaining reasonable height unless space won't allow it. The wider the base, the more stable the setup.

Adjust Leg Length for Camera Height
As far as possible, establish camera height by extending the tripod legs rather than the center column. Extending the legs makes the setup more stable. Raising the column excessively makes it more tippy. Raise the center column only for minor height adjustments. When you don't need the full height of the tripod, extend the thicker portions of the legs first, and as little of the thinner portions of the legs as necessary, for a firmer tripod.

Lock All Settings
Use the tripod clamps or lock rings to lock all adjustments securely. The tripod will be more rigid and the camera won't sag or creep out of position. Don't operate locking devices too forcefully, though, particularly rotating collars, or they may freeze into position and require tools to unlock. And keep locking mechanisms clean and free of grit or sand, which accelerate wear and can cause jamming.

Attach the Camera with Care
When you engage the tripod mounting screw in the camera tripod socket, stop turning the screw when it is just barely finger-tight. Forcing the screw deeper than it should go can cause serious internal damage to the camera as well as external blemishes.

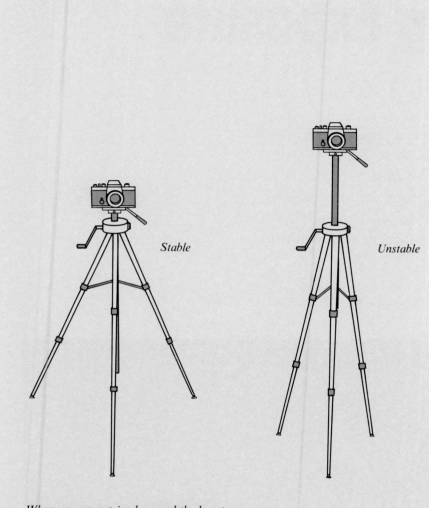

Stable

Unstable

When you use a tripod, spread the legs to a wide position to create a broad, stable footing (left). Don't spread them partially (right) unless you are in a cramped area that doesn't permit full deployment. Position the camera at the height you need by extending the tripod legs, and use the center column for minor adjustments (left). Raising the center column excessively (right) decreases stability.

Shake-Free Exposures

For consistently sharp exposures with a tripod-mounted camera, use a cable release to trip the shutter. If the camera rests on an improvised support and you don't have a cable release with you, hold the camera in place firmly with one hand while gently pressing the shutter release with the other. If the subject is immobile, you can also use the self-timer, if your camera has one, to release the shutter without jarring the camera.

Some SLR cameras have a mirror release that lets you swing the reflex mirror out of the light path. Then you can stop down the lens to the taking aperture before tripping the shutter. If your camera has this feature, actuate the control several seconds before making the exposure so any mechanical vibrations will stop before the shutter opens.

You can easily learn the techniques for making better existing-light pictures outlined in this chapter with a little practice. The best way to practice is during your everyday picture-taking. Just as they improve existing-light pictures, they will improve the pictures you make under less challenging conditions.

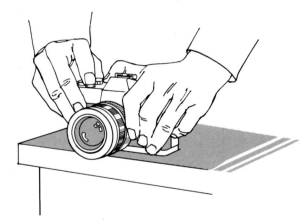

To trip the shutter with minimal vibration when you don't have a cable release, press the camera firmly against a steady support with one hand while pressing the shutter button gently. You can use this technique with the camera on an improvised support or on a tripod.

Determining Exposure

Differences between existing light and familiar outdoor daylight conditions are reflected in methods used to determine exposure. Existing light is nearly always dimmer. It is frequently less evenly distributed. It may come from several different sources and directions simultaneously. And the light sources themselves are sometimes the subjects of existing-light photographs. Although the basic principles of determining existing-light exposure are the same as for daylight photography, you may have to apply them differently for best results.

The light sources themselves are sometimes the subjects of existing-light photographs.

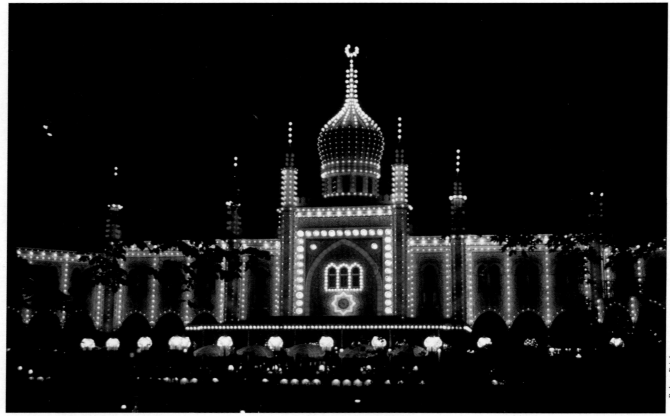

Robert Brink

sure adjustments based on experiences with your particular camera meter. Otherwise, follow the adjustments we suggest.

Most automatic single-lens reflex cameras allow the user to alter the exposure, while automatic non-reflex cameras with direct-optical viewfinders allow limited or no user control of exposure.

You can control the exposure with your automatic camera if it has one or more of the following features:

- Manual mode for setting camera exposures.
- Exposure-compensation dial for increasing or reducing exposure.
- Shutter release with a partial-pressure feature or a lever for holding a meter reading before taking the picture, useful for making close-up or other selective meter readings.
- Backlighting control for increasing exposure, usually by 1 1/2 or 2 stops.
- Film-speed dial that lets you set a higher or lower ISO speed than the speed of the film you're using. For example, for a 400-speed film, setting the ISO film-speed dial at 200 would produce 1 stop more exposure; setting the dial at 800 would produce 1 stop less exposure.

Your camera manual will tell you if your camera has any of these features. Then you can correct the exposure for the types of scenes that are difficult to meter as suggested in this book. Or you can compare the exposure determined by your camera, if it indicates shutter speed and lens opening, with the exposures in the tables on pages 42 and 43; if your camera indicates an exposure very different from the ones in the table, adjust your camera to match the settings in the table.

The World as Exposure Meters "Think" They See It

Both reflected- and incident-light exposure meters are designed with the same assumption that most subjects, most of the time, are of average tone and reflectance. The average indoor scene has a reflectance equal to a medium gray of 18 percent. This is the reasoning behind neutral gray cards, such as KODAK Gray Cards, which have 18-percent reflectance, sometimes used as a substitute

from which to obtain an average exposure-meter reading. For more on these gray cards, see page 38.

Reflected-light meters assume that you are pointing them at a medium-gray world, so their exposure recommendations for the subject they measure will record it on film as a medium gray or an equivalent brightness in color. This will help you in your visualization of how the exposure will appear on the film. Normal exposure-meter readings are fine for average-tone subjects because they usually should be recorded on film as medium-tone brightnesses. But if your meter measures a large bright or dark area in the scene, the indicated exposure will make that area appear as a medium-tone brightness in the picture and give incorrect exposure. You must adjust your exposure in these situations to obtain correct exposure.

Many existing-light scenes, especially those outdoors at night, are predominantly darker than average subjects. When a normal reflected-light meter reads such a scene, the exposure settings indicated by the meter will appear equiv-

If the subject is unusually light, increase the exposure indicated by a reflected-light meter by 1/2 to 1 stop. KODAK EKTACHROME 160 Film (Tungsten) with Push-1 Processing.

Tom Beelmann

An exposure based on a reflected-light reading directly from a light source will reproduce the light source darker and more saturated in color than the light actually looked. Increasing the exposure by 1/2 to 1 stop over the meter indication will usually give a more accurate rendition. Here a full stop of additional exposure brightened the lights. KODAK EKTACHROME 160 Film (Tungsten), 1/30 second between f/4 and f/5.6.

alent in brightness to medium gray on film. When you meter scenes that are darker than usual with a reflected-light meter, adjust the exposure settings to give about 1/2 to 1 full stop less exposure than the meter recommends. This will keep the picture from appearing lighter than the original scene.

Conversely, if the subject is an unusually light element in the scene or is actually a light source, a reflected-light meter reading of the light areas or light source will provide exposure information to record them with a brightness equivalent to medium gray and underexpose them. To avoid this overly dark rendition, set the camera to give approximately 1/2 to 1 stop more exposure than the meter indicates.

An incident-light meter measures only the intensity of the light falling on it and indicates an exposure that assumes a subject of normal brightness. With an average subject in a dark existing-light scene, the basic reading will yield an exposure that records the scene much as it looks to your eye. The meter makes no attempt to

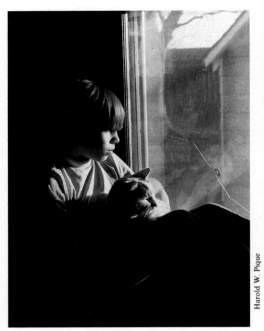

Harold W. Pique

An incident-light meter ignores subject and background characteristics of the scene and provides exposure information to give an accurate rendition of average subjects. Here an incident-light reading made near the subject's face would indicate the correct exposure and ignore the dark surroundings.

"correct" for the dark areas surrounding the subject. Also, you generally don't have to adjust an incident-light meter reading to preserve the mood of the scene with average subjects in lighter-than-average surroundings, provided you want the photo to look light, as the scene appeared.

When the subject itself, not the surroundings or the illumination, is lighter than average, it will record lighter, and when the subject is darker than average, it will record darker if you take an incident-light meter reading at face value. Most of the time, the rendition will be appropriate when the subject is only somewhat lighter or darker than average. However, when the subject is much lighter or darker than average, you should alter the exposure indicated by an incident-light meter. For unusually light subjects, decrease exposure by 1/2 to 1 stop; for unusually dark subjects, increase exposure by 1/2 to 1 stop. Note

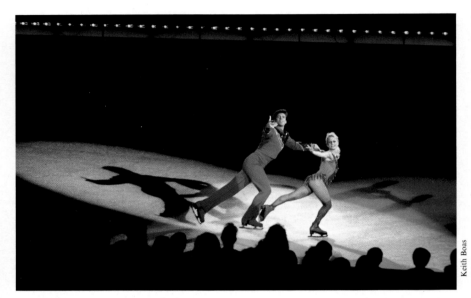

Keith Boas

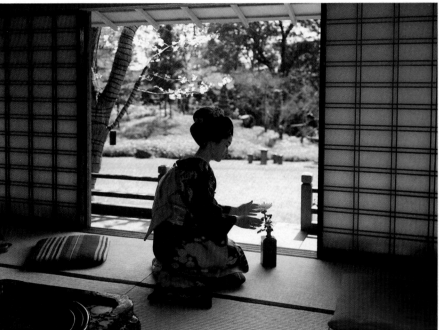

Lee Howick

When performers, such as the Ice Capades skaters, are lighted by spotlights with a dark surround, an averaging reflected-light exposure meter would read too much dark background and overexpose the performers. Conversely, when a subject is backlighted by window light, an averaging meter would read the bright background and react as if the

whole scene was lighter than usual and underexpose the subject. A reflected-light spot meter would limit the metered area to significant parts of the subject, and ignore the irrelevant background to help achieve correct exposure. You can obtain similar selectivity with an averaging meter if you can approach the subject and make a close-up reading.

that these corrections are just the opposite of those required for a reflected-light meter.

An important exception to this rule involves photographing light sources. An incident meter is of little help, because it cannot correctly measure the light source directly. For photographing light sources, you're better off determining exposure with a reflected-light meter or an exposure table.

Exposure-Meter Coverage

Reflected-light meters, like lenses, have a wide or narrow angle of view. Meters that read a fairly wide angle of view are called averaging meters. They present exposure data based on the average of light and dark areas in the scene. Most hand-held meters and built-in light meters in cameras are averaging types. They are quick and easy to use and don't require much decision-making most of the time. If you use an averaging meter, remember that it will attempt to give more exposure than necessary when it reads a scene with large dark areas, such as a well-lighted performer standing on an otherwise dark stage. The same meter would tend to underexpose the performer if the background were substantially lighter or brighter.

Narrow-angle reflected-light meters have a restricted reading angle, and you can aim them selectively at limited areas of the scene. Meters with extremely narrow reading angles are called spot meters. Spot meters and narrow-angle meters require more skill and judgment to use successfully, but reward the careful worker with precise exposure measurement. They are extremely useful for calculating exposure when a relatively small significant subject area appears against much lighter or darker surroundings. Spot meters are handy for existing-light theatrical and sports subjects and for making meter readings directly from light sources when you want to photograph the lights themselves. They are somewhat slow to use well for general photography because you must be careful to read small important areas. You may have to make a series of readings of different important subject areas and then average them to determine an overall exposure.

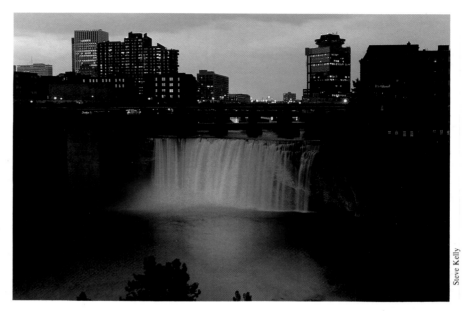

Steve Kelly

A sensitive exposure meter is helpful in calculating exposure in low light. However, if you can't make an accurate meter reading because the scene is too dim for your meter to respond or is not suitable for making a reading, you can often manage well by referring to an exposure table.

Center-weighted, reflected-light exposure meter systems offer a compromise between spot and averaging systems. Major reading emphasis is placed on the central portion of the field because the principal subject is usually in that location in the frame, but outer regions also influence the exposure recommendation. The numbers indicate percentages of sensitivity.

Many 35 mm SLR cameras incorporate center-weighted reflected-light metering systems that represent a compromise between averaging and spot meters. Center-weighted exposure meters typically read everything in the field of view of the lens but are more influenced by the central portion of the field than by the edges. When you use a center-weighted meter, determine exposure with the primary subject centered in the meter field—usually the center of the viewfinder (see your camera manual); then reframe the scene if necessary for best com-

position. With an automatic camera, you may have to use an exposure-hold system or switch to manual mode to prevent the exposure from changing when you reframe the scene.

Exposure-Meter Sensitivity

For existing-light photography, the term exposure-meter sensitivity refers primarily to the ability to respond accurately to dim light. The more sensitive the meter is, the lower the light levels in which you can use it. Nearly all modern battery-powered exposure meters are capable of reading in light dim enough to require high-speed film for hand-held photography. Some extremely sensitive meters can easily read in light so dim that you would have to use a tripod, high-speed film, and lengthy exposures to record a usable image. If your exposure meter doesn't respond adequately in low light, you can make a substitute reading from a piece of white paper or a white card to get a higher meter reading. This technique is explained on page 38. If this is impractical, you can still make good existing-light pictures by referring to exposure tables.

EXPOSURE UNDER EVEN ILLUMINATION

It's generally easy to determine exposure in even lighting because you don't have to be concerned with extremely bright and dark areas in the same scene. As long as the scene doesn't include unusually reflective or nonreflective subjects of importance, an overall average reading will give you good exposure. Even lighting is especially helpful when your subject is moving about, because no matter where the subject goes, the exposure is likely to remain the same. To verify that the lighting is even, make several exposure readings of different parts of the scene. If they are all the same or within a stop or less of each other, the lighting is even enough for you to photograph freely at the same exposure setting as long as the lighting doesn't change.

If you need more film speed with a specific film and it is a type that can be push-processed, you will be able to double the film-speed number with a corresponding processing adjustment when necessary and still obtain excellent results in even lighting.

EXPOSURE UNDER UNEVEN ILLUMINATION

Many existing-light scenes are characterized by uneven lighting; some parts of the photographic field are brightly illuminated while others are quite dark. This often makes the picture more interesting and natural looking. There are several ways to deal with such scenes, depending on how you want the picture to look.

Meter the Extremes

One way to determine exposure for uneven illumination is to make exposure-meter readings in the most important areas and then use a midpoint exposure. Begin by making meter readings of the lightest and darkest important areas where you want to see detail. Determine the number of *f*-stops separating them. Don't include in your sample unimportant areas, such as glaringly bright elements like light bulbs or pitch-black shadows in which you don't need to see detail and texture.

An overall reading with an averaging exposure meter provides good exposure data for evenly lighted subjects that include no prominent areas that are unusually light or dark.

Calculating exposure for unevenly lighted scenes such as this one requires metering both light and dark areas, then interpreting the readings to produce a picture that looks the way you want it to look. KODAK EKTACHROME 160 Film (Tungsten).

With color-negative and color-slide films, you can obtain reasonable exposure if the overall range from lightest important area to darkest important area is 6 stops or less by setting the camera for the midpoint of the range. You can expose most black-and-white films at a midpoint setting when the range is 8 stops or less and get excellent results. Exposure determined this way will provide conventional scene rendition. Light areas will look light, medium-tone areas will be medium-toned, and dark areas will look dark in the picture. This assumes proper printing of negative films. Many scenes with even greater exposure ranges frequently look good in photographs made at the midpoint exposure. This is because the midpoint exposure is usually good for the main subject, and viewers don't expect to see detail in deep shadows or brilliant highlights near light sources.

Decide What Matters Most

If you wish to produce a picture that is more an interpretation than a standard rendition, or if the metered range in a situation exceeds the limits of the film you are using, you will need to make some decisions. First decide what you wish to show most clearly, such as the main subject, and make a meter reading of that area. Then set your camera for an exposure that will show the area with best tone rendition, keeping in mind that a normal exposure-meter reading will make the metered area record on the film as a medium brightness.

Next, consider the effect that exposure setting will have on lighter and darker areas in the picture. If you are likely to record large areas of over- or underexposed surroundings that should show detail and that will detract from the subject, change your point of view or shooting distance to exclude them from the frame. If bright lights in the picture area are a problem in a home, use a camera angle that excludes them or move them out of the camera view. You could also turn them off, but that means lowering the light level. Usually when photographing in home lighting, you need as much illumination as possible from the existing lighting. Also, the existing room lights make the lighting more even and natural.

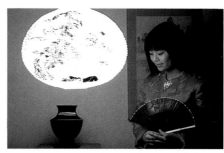
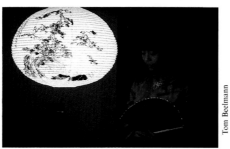

When people are prominent in the scene, choose an exposure that favors good skin-tone rendition, unless you are striving for a special effect, such as a silhouette. Viewers are less tolerant of improper skin-tone rendition than they are of other subject matter. Even though the picture on the bottom (above) shows good detail in the lamp, the picture on the top is obviously better because it shows better detail for the woman. KODAK EKTACHROME 160 Film (Tungsten).

In harsh, contrasty lighting, it is usually better to favor good highlight and mid-tone exposure, even if it means losing considerable detail in darker areas. Exposing for darker values often creates unacceptable overexposed bright areas, especially with color-slide films. KODAK EKTACHROME 160 Film (Tungsten), 1/8 second f/8.

As a rule, if people are prominent in the scene, expose for good skin-tone rendition even if it means sacrificing other areas a bit. Viewers are less tolerant about how people look than they are about the appearance of inanimate objects.

With lighting that is not only uneven but also harsh and contrasty, forget about trying to retain much detail and texture in darker areas. Exposing for significant highlights and middletones and letting the rest of the picture go dark can produce stark, dramatic pictures. Exposing for darker areas in such cases usually leads to unacceptable overexposure of highlights which are usually more important than dark shadows. This is particularly true with color-slide films.

If you must expose film at a higher film-speed number in harsh lighting and then push-process it, use exposure settings to favor skin tones and the brighter parts of the scene. Push processing increases film contrast, which makes burned-out highlights more likely if you have exposed for the shadows.

SUBSTITUTE EXPOSURE-METER READINGS

When you're unsure what part of a scene is the most suitable area to measure with a reflected-light meter, or if you cannot make a close-up meter reading of a significant area properly, make a close-up reading of the palm of your hand and set the camera for 1 stop more exposure than the meter indicates. That exposure will be suitable for scenes with average distribution and intensity of light and dark areas and will be right for skin tones, too. For dark skin, use 2 stops more exposure than the meter indicates from the palm reading. Make sure your hand is lighted in the same way as the scene you're photographing. Place your exposure meter or camera with built-in meter close enough to fill its field of view with your hand, and make sure the meter, the camera, or part of your body is not casting a shadow on your hand. Readings made this way are similar to readings made from a gray card or readings with an incident-light meter.

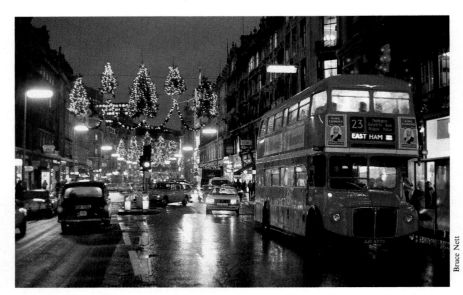

With lighted areas and lights both prominent in the scene, the best exposure is usually halfway between the exposure *for the lights and the exposure for dimly lighted areas. 1000-speed Kodak film, 1/125 second f/4.*

In very dim light you can sometimes get an adequate exposure-meter reading from a white card when your meter doesn't respond sufficiently to a direct reading of the subject. Divide the film speed by 5 and reset the calculator on your exposure meter or the film-speed dial on your camera to the lower number, and make a white-card reading. The lower film-speed setting compensates for the greater-than-average reflectivity of the white card. Reset your meter or camera to the normal film speed immediately after you are finished with the white card.

Since the brightness of people's palms may vary to some extent from one person to another, it's a good idea to compare an exposure-meter reading of your palm with a meter reading of a gray test card of known reflectance. You can do this with *KODAK Gray Cards,* Publication R-27. These 4 x 5- and 8 x 10-inch cards are sold by photo dealers and include instructions for their use.

Just hold your palm and a KODAK Gray Card so that they're both lighted by the same even light. Normally, the meter reading of your palm should indicate 1 stop less exposure than the reading of the gray card. If the difference is only +1/2 stop for your palm, use this factor to adjust exposures for other subjects based on meter readings of your hand.

You can also use the KODAK Gray Card for making substitute exposure-meter readings. See the instructions included with the cards.

If the light is too dim for your exposure meter to give accurate readings, reset the film-speed dial to 1/5 the actual ISO speed of the film you are using. Then aim the meter at a white card or a sheet of white paper that is illuminated in the same way as the subject. You can use the white reverse side of the KODAK Gray

Card for this. The white target reflects about 5 times as much light as an average subject, so it may jog the meter into providing an adequate response for a reliable reading. Dividing the film speed by 5 compensates for the fact that the meter is reading 5 times more brightness than it normally would from an average subject. After you have determined the exposure by this method, to make readings normally, reset the meter dial to the actual speed of your film. Otherwise the meter will provide grossly inaccurate exposure recommendations.

USING EXPOSURE METERS OUTDOORS AT NIGHT

Existing-light picture opportunities outdoors at night fall into three main subject categories: those in which the subject consists of both lights and lighted areas; those in which the subject is lighted but is not a light source; and those in which the subject is one or more light sources.

Exposing for Lighted Areas That Include Lights

General exposure-meter readings of scenes that include both lighted areas and lights that will appear in the picture provide a sound data base from which to im-

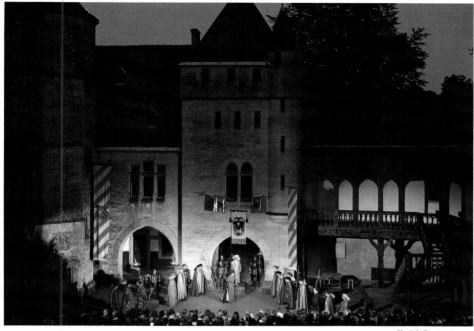

Kodak Stuttgart

When you use an exposure meter outdoors at night, exclude large dark areas surrounding the subject to avoid deflated readings that can result in overexposure of the main subject. A good method is to make close-up or spot-meter readings of the subject so that the meter does not measure the dark surroundings. Also, when light sources are an essential part of the scene, exclude the lights when you make your meter reading. The lights can cause inflated readings and underexposure. Again the solution is to make close-up or spot-meter readings.

provise, as long as no large dark areas cause the meter to indicate camera settings that would produce overexposure. If the scene is fairly evenly lighted and relatively small light sources will appear in the picture, and there are no large dark areas, expose at the meter recommendation. If there are large lights or large black areas in the scene, decide where you want to place the visual emphasis in the picture and expose accordingly. If you expose for the lights, less bright areas will tend to be underexposed and will appear darker in the picture than they may have seemed in reality. If you opt instead for realistic rendition of the areas that are dimly lighted, the lights in the scene will be overexposed and somewhat washed out. Each specific scene and your personal tastes will dictate the best exposure choice.

Usually a compromise exposure, based on close-up meter readings, that records some detail in both lighted areas and lights in the scene is the best choice. Fortunately, exposure for outdoor night scenes is not critical and more than one exposure is usually acceptable.

For scenes that are difficult to meter, such as those with large dark areas, you may obtain better exposure by following the exposure tables in this book. See pages 42 and 43. If the exposure indicated by your exposure meter differs significantly from the exposure suggested in the table, take pictures at both camera settings, bracket, and choose the picture with the best exposure. This will help you gain experience for similar situations.

Automatic cameras tend to overexpose scenes outdoors at night because of the large areas of darkness surrounding lighted subjects. Night skies may be reproduced as a medium tone and lighted subjects may be washed out and lack detail. If your automatic camera indicates the lens opening and shutter-speed settings determined by the exposure-meter system and has one of the features for altering exposure described on page 33, you may be able to correct the camera settings to give proper exposure. To determine the exposure settings, you can make selective meter readings of the lighted areas or use the exposures in the tables on pages 42 and 43. You can also bracket your exposures.

Exposing for Lighted Subjects

You can make exposure-meter readings of floodlighted buildings, monuments, and sports arenas as though they were ordinary daytime subjects if you take extra precautions. Make sure your exposure meter reads as much of the subject as possible and that it is not influenced excessively by light sources in its field of view or by unusually large dark areas surrounding the subject. Either aim your meter to exclude such areas or make close-up readings.

Instead of close-up meter readings, a spot meter will help save footsteps. With an SLR camera, you can read the exposure through a telephoto lens to limit the meter's field of view, and then switch to whatever focal-length lens frames the scene best. You can also do this with a zoom lens by making the meter reading with the lens at the telephoto setting.

If possible, exclude light sources that produce large bright spots from the frame when you make the exposure. This helps to avoid distracting hot spots in the picture. Often, though, the light sources are not distracting and add to the dramatic appearance of a night subject. Sometimes the glare is blocked by reflectors on the light sources. It's rewarding to experiment and photograph the subject from several viewpoints, including or excluding light sources in different pictures. Then you can choose the best one.

When you read exposure for lights themselves, fill the meter field with the lights and exclude dark surroundings that might trick the meter into recommending overexposure. Usually the normal exposure indicated by a reflected-light meter reading of colored lights produces good results. KODAK EKTACHROME 160 Film (Tungsten), 1/60 second f/4.

Exposure for Photographing Light Sources

When light sources, such as colorful signs or decorative lights at an amusement park are the primary subject, make exposure-meter readings directly from the light sources and exclude as much of the dark surround as possible. If necessary, approach a cluster of typical lights closely enough to fill the meter's field of view, or make a spot or telephoto-lens reading to exclude the dark surroundings.

Taking the meter reading at face value will yield color slides with good color saturation in the colored lights and little perceptible detail in darker areas. Increasing the exposure by 1 stop will give brighter lights with less saturation and increased detail in darker areas. Decreasing the exposure by 1 stop from the meter reading will further saturate the colors of the lights and make the rest of the scene even darker. Hedge your bets by shooting all three exposure variations; then pick the version you like best. You can also use these exposure guidelines for col-

or and black-and-white negative films to obtain proper exposure, but tone rendition is controlled to a large extent when the prints are made.

WHEN IN DOUBT, BRACKET EXPOSURES

Bracketing exposure consists of taking one picture at the shutter speed and *f*-stop determined by your exposure meter, recommended in an exposure table, or based on your best estimate of what the situation requires, then taking additional pictures with more and less exposure. Bracketing is indispensable to existing-light photography. It provides insurance that you will produce acceptable pictures in unfamiliar situations and before you gain experience with existing-light subjects. If you are slightly uncertain about the best exposure setting, bracket by 1 stop. If you are very uncertain, extend the bracketing range to 2 stops or more. For more subtle control, bracket in 1/2-stop increments. With color-negative and black-and-white negative films, bracket more on the side of overexposure unless the scene includes important light areas that should not be overexposed. These films are more tolerant of overexposure than underexposure.

Usually, with color and black-and-white negative films, 1-stop exposure increments are appropriate because of the films' exposure latitude. Since color-slide films have less latitude, 1/2-stop increments are usually better for existing-light subjects.

USING EXPOSURE TABLES

Sometimes it is difficult or impossible to determine correct exposure with an exposure meter. The reasons may range from "I forgot to replace the dead meter battery" to "I haven't the faintest idea where to point it." That's where exposure tables come to the rescue. Exposure tables are guides that give suggested exposures with various films for a variety of existing-light or other photographic situations. The exposure data are derived from pictures made by experienced photographers using properly functioning photographic equipment. Instructions for some Kodak films include existing-light exposure tables.

One stop more exposure, 1/60 second f/2

Normal exposure, 1/60 second f/2.8

One stop less exposure, 1/60 second f/4

Bracketing consists of making several exposures of the same subject at different exposure settings. The examples above are 1 stop over the exposure indicated by the meter reading—more exposure; the normal exposure; and 1 stop under—less exposure. Think of bracketing as picture insurance. KODAK EKTACHROME 160 Film (Tungsten).

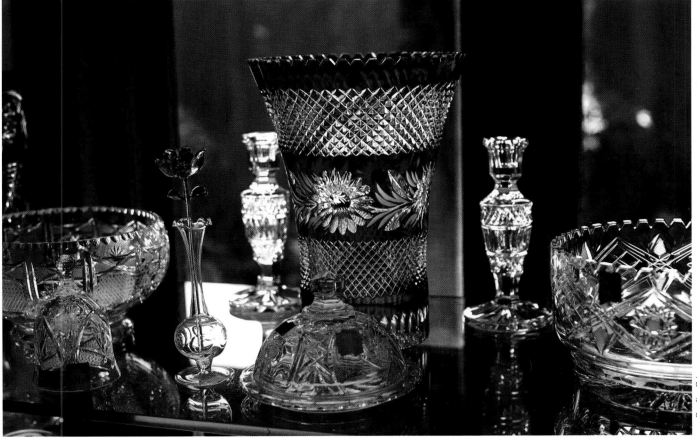

Caroline Grimes

The information in exposure tables is sometimes in the form of a dial-calculator exposure guide. The KODAK Pocket Photoguide, AR-21, sold by photo retailers, includes a convenient existing-light exposure dial.

When you use an exposure table, remember that the exposures are for typical subjects and lighting conditions and assume that equipment is operating correctly. Because of variations in subjects, scenes, and cameras and lenses, it's advisable to bracket your exposure for important pictures.

These tables can also play an important role in helping you learn to use an exposure meter well in existing light. Compare meter readings you make with the exposures recommended in the table. When they are the same or fairly similar, you're using your meter properly. If the settings your meter recommends differ

significantly from those the table suggests, examine your metering technique because you may be doing something incorrectly. If your readings and the exposure table differ consistently with a variety of subjects and you are getting poor exposure with your readings, have your meter checked for accuracy and adjusted if necessary.

Exposure tables provide another helpful function; they're useful for planning purposes. The suggested exposures can help you select film and lenses with adequate speed for the kinds of subjects and lighting conditions you expect to encounter. Exposure tables for existing light may also suggest new subjects for pictures that had not occurred to you.

The more experience you acquire using exposure tables, the more you will appreciate how helpful these simple "paper exposure meters" can be.

Glassware in a window with daylight shining through it is a subject that's difficult to read with an exposure meter for correct exposure because of the bright background. This is a situation where an exposure table can help. Usually an exposure 1 stop greater than that required for the outdoor lighting gives good results. KODACHROME 64 Film (Daylight), 1/60 second f/8.

41

Picture Subject	ISO 25	ISO 40	ISO 50-64	ISO 100-125	ISO 160-200	ISO 320-400	ISO 800-1000	ISO 1600		
AT HOME										
Home interiors at night—Areas with average light	—	1/4 sec f/2	1/4 sec f/2.8	1/15 sec f/2	1/30 sec f/2	1/30 sec f/2.8	1/30 sec f/4	1/60 sec f/4		
Areas with bright light	1/4 sec f/2	1/8 sec f/2	1/15 sec f/2	1/30 sec f/2	1/30 sec f/2.8	1/30 sec f/4	1/60 sec f/4	1/60 sec f/5.6		
Candlelighted close-ups	—	—	1/4 sec f/2	1/8 sec f/2	1/15 sec f/2	1/30 sec f/2	1/30 sec f/2.8	1/30 sec f/4		
Indoor and outdoor holiday lighting at night Christmas trees	1 sec f/2	1 sec f/2.8	1 sec f/4	1 sec f/5.6	1/15 sec f/2	1/30 sec f/2	1/30 sec f/2.8	1/30 sec f/4		
OUTDOORS AT NIGHT										
Brightly lighted downtown street scenes (Wet streets add interesting reflections.)	1 sec f/5.6	1/15 sec f/2	1/30 sec f/2	1/30 sec f/2.8	1/60 sec f/2.8	1/60 sec f/4	1/125 sec f/4	1/125 sec f/5.6		
Brightly lighted nightclub or theatre districts—Las Vegas or Times Square	1/15 sec f/2	1/30 sec f/2	1/30 sec f/2.8	1/30 sec f/4	1/60 sec f/4	1/125 sec f/4	1/125 sec f/5.6	1/125 sec f/8		
Neon signs and other lighted signs	1/30 sec f/2	1/30 sec f/2.8	1/30 sec f/4	1/60 sec f/4	1/125 sec f/4	1/125 sec f/5.6	1/125 sec f/8	1/125 sec f/11		
Store windows	1/15 sec f/2	1/30 sec f/2	1/30 sec f/2.8	1/30 sec f/4	1/60 sec f/4	1/60 sec f/5.6	1/60 sec f/8	1/60 sec f/11		
Subjects lighted by street lights	—	—	1/4 sec f/2	1/8 sec f/2	1/15 sec f/2	1/30 sec f/2	1/30 sec f/2.8	1/30 sec f/4		
Floodlighted buildings, fountains, monuments	1 sec f/2	1 sec f/2.8	1 sec f/4	1/2 sec f/4	1/15 sec f/2	1/30 sec f/2	1/30 sec f/2.8	1/30 sec f/4		
Skyline—immediately after sunset	1/30 sec f/2.8	1/30 sec f/4	1/60 sec f/4	1/60 sec f/5.6	1/125 sec f/5.6	1/125 sec f/8	1/125 sec f/11	1/250 sec f/11		
Skyline—10 minutes after sunset	1/30 sec f/2	1/30 sec f/2.8	1/60 sec f/4	1/60 sec f/4	1/60 sec f/5.6	1/125 sec f/5.6	1/125 sec f/8	1/125 sec f/11		
Skyline—distant view of lighted buildings at night	8 sec f/2	4 sec f/2	4 sec f/2.8	1 sec f/2	1 sec f/2.8	1 sec f/4	1 sec f/5.6	1 sec f/8		
Moving auto traffic on expressways—light patterns	20 sec f/8	20 sec f/11	20 sec f/16	10 sec f/16	10 sec f/22	10 sec f/32	5 sec f/32	3 sec f/32		
Fairs, amusement parks	—	1/15 sec f/2	1/15 sec f/2	1/30 sec f/2	1/30 sec f/2.8	1/60 sec f/2.8	1/60 sec f/4	1/125 sec f/4		
Amusement-park rides—light patterns	4 sec f/8	4 sec f/11	4 sec f/16	2 sec f/16	1 sec f/16	1 sec f/22	—	—		
Fireworks—displays on the ground	1/15 sec f/2	1/30 sec f/2	1/30 sec f/2.8	1/30 sec f/4	1/60 sec f/4	1/60 sec f/5.6	1/60 sec f/8	1/60 sec f/11		
Fireworks—aerial displays (Keep shutter open on Bulb for several bursts.)	f/4	f/5.6	f/8	f/11	f/16	f/22	f/32§	f/32§		
Lightning (Keep shutter open on Bulb for one or more streaks of lightning.)	f/2.8	f/4	f/5.6	f/8	f/11	f/16	f/22	f/32		
Burning buildings, campfires, bonfires (flames)	1/15 sec f/2	1/30 sec f/2	1/30 sec f/2.8	1/30 sec f/4	1/60 sec f/4	1/125 sec f/4	1/125 sec f/5.6	1/125 sec f/8		
Subjects lighted by campfires, bonfires	—	—	1/8 sec f/2	1/15 sec f/2	1/30 sec f/2	1/30 sec f/2.8	1/30 sec f/4	1/60 sec f/4		
Night football, soccer, baseball, racetracks			1/15 sec f/2	1/30 sec f/2	1/30 sec f/2.8	1/60 sec f/2.8	1/125 sec f/2.8	1/250 sec f/2.8	1/250 sec f/4	1/500 sec f/4
Niagara Falls—White lights	15 sec f/2.8	15 sec f/2	15 sec f/5.6	8 sec f/5.6	4 sec f/5.6	4 sec f/8	4 sec f/11	2 sec f/11		
Light-colored lights	30 sec f/2.8	30 sec f/2	30 sec f/5.6	15 sec f/5.6	8 sec f/5.6	4 sec f/5.6	4 sec f/8	4 sec f/11		
Dark-colored lights	30 sec f/2	30 sec f/2.8	30 sec f/4	30 sec f/5.6	15 sec f/5.6	8 sec f/5.6	4 sec f/5.6	4 sec f/8		
Moonlit¶—Landscapes	—	—	30 sec f/2	15 sec f/2	8 sec f/2	4 sec f/2	4 sec f/4	4 sec f/4		
Snow scenes	—	—	15 sec f/2	8 sec f/2	4 sec f/2	4 sec f/2.8	4 sec f/4	4 sec f/5.6		
Sydney, Australia—Opera House	1 sec f/2.8	1/2 sec f/2.8	1/4 sec f/2.8	1/15 sec f/2	1/30 sec f/2	1/30 sec f/2.8	1/30 sec f/4	1/60 sec f/4		
Sydney Harbour Bridge	1 sec f/2	1 sec f/2	1/2 sec f/2.8	1/4 sec f/2.8	1/15 sec f/2	1/30 sec f/2	1/30 sec f/2.8	1/60 sec f/2.8		
El Alamein Memorial Fountain	4 sec f/2	4 sec f/2	1 sec f/2	1 sec f/2.8	1/2 sec f/2.8	1/4 sec f/2.8	1/15 sec f/2.8	1/30 sec f/2		

SUGGESTED EXISTING-LIGHT EXPOSURES FOR *KODAK* FILMS Continued

OUTDOORS AT NIGHT

Subject	Col 1	Col 2	Col 3	Col 4	Col 5	Col 6
Canada—Skyline-close view, Toronto, Ontario	4 sec f/2.8	1 sec f/2.8	1 sec f/2	1/2 sec f/2.8	1/4 sec f/2	1/30 sec f/2.8
Château Frontenac, Quebec, Quebec	1 sec f/2	1 sec f/2	1/2 sec f/2	1/4 sec f/2.8	1/15 sec f/2	1/30 sec f/4
Parliament Building, Victoria, British Columbia	1/2 sec f/2.8	1/4 sec f/2.8	1/4 sec f/2.8	1/15 sec f/2.8	1/30 sec f/2	1/60 sec f/5.6
Copenhagen, Denmark—Town Hall Square	1 sec f/2	1 sec f/2.8	1 sec f/2	1/2 sec f/2.8	1/4 sec f/2.8	1/60 sec f/2.8
Little Mermaid	4 sec f/2.8	4 sec f/2.8	2 sec f/2	1/2 sec f/2	1/2 sec f/2.8	1/30 sec f/2.8
The Restaurant Nimb, Tivoli Gardens	1/2 sec f/2.8	1/2 sec f/2.8	1/4 sec f/2.8	1/30 sec f/2	1/30 sec f/2.8	1/125 sec f/4
England—Trafalgar Square; Piccadilly Circus; Leicester Square; Regent Street and Oxford Street Christmas Lighting, London	1/4 sec f/2	1/4 sec f/2.8	1/30 sec f/2.8	1/60 sec f/4	1/125 sec f/2.8	1/250 sec f/4
Golden Mile, Blackpool	1 sec f/2	1 sec f/2.8	1/2 sec f/2	1/30 sec f/2	1/15 sec f/2	1/60 sec f/2.8
Paris, France—Eiffel Tower	1/2 sec f/2.8	1/2 sec f/2.8	1/4 sec f/2	1/30 sec f/2.8	1/30 sec f/2.8	1/60 sec f/4
Arc de Triomphe	1/4 sec f/2.8	1/4 sec f/2.8	1/15 sec f/2	1/30 sec f/2.8	1/60 sec f/2.8	1/125 sec f/4
Germany—Dom Cathedral from Deutzer Ufer, Cologne; Rothenburg on the Tauber, Rothenburg; Heidelberg Castle, Heidelberg	1/2 sec f/2.8	1/4 sec f/2.8	1/30 sec f/2.8	1/30 sec f/2.8	1/60 sec f/2.8	1/60 sec f/5.6
Rome, Italy—Esedra Fountain; Navona Fountain	1 sec f/2	1 sec f/2.8	1/4 sec f/2	1/15 sec f/2	1/30 sec f/2.8	1/60 sec f/2.8
Roman Forum; Coloseum	8 sec f/2	4 sec f/2	1 sec f/2	1/2 sec f/2.8	1/4 sec f/2.8	1/8 sec f/2.8
Tokyo, Japan—Ginza Street; Kabuki Theater	1/4 sec f/2	1/15 sec f/2	1/30 sec f/2.8	1/60 sec f/2.8	1/125 sec f/4	1/250 sec f/4
Shinjuku Skyscrapers	1/2 sec f/2.8	1/4 sec f/2.8	1/30 sec f/2.8	1/30 sec f/2.8	1/60 sec f/4	1/60 sec f/4
Mexico City, Mexico—Independence Monument; Virgin of Guadalupe Shrine Interior	1 sec f/2.8	1/2 sec f/2.8	1/4 sec f/2.8	1/30 sec f/2.8	1/30 sec f/2.8	1/60 sec f/4

INDOORS IN PUBLIC PLACES

Subject	Col 1	Col 2	Col 3	Col 4	Col 5	Col 6
Basketball, hockey, bowling°	—	—	1/30 sec f/2	1/125 sec f/2	1/250 sec f/2.8	1/500 sec f/2.8
Boxing, wrestling°	—	1/30 sec f/2	1/60 sec f/2	1/125 sec f/2	1/250 sec f/2	1/500 sec f/4
Stage shows—Average	1/30 sec f/2	1/15 sec f/2	1/30 sec f/2	1/30 sec f/2.8	1/125 sec f/2.8	1/250 sec f/4
Bright	1/15 sec f/2	1/60 sec f/2	1/60 sec f/2.8	1/60 sec f/4	1/250 sec f/4	1/500 sec f/5.6
Circuses—Floodlighted acts	—	—	1/30 sec f/2	1/60 sec f/2.8	1/250 sec f/2.8	1/500 sec f/2.8
Spotlighted acts (carbon-arc)	1/30 sec f/2	1/60 sec f/2	1/60 sec f/2.8	1/125 sec f/2.8	1/250 sec f/4	1/500 sec f/5.6
Ice shows—Floodlighted acts	—	1/30 sec f/2	1/30 sec f/2	1/125 sec f/2.8	1/250 sec f/2.8	1/500 sec f/2.8
Spotlighted acts (carbon-arc)	1/30 sec f/2	1/60 sec f/2	1/60 sec f/2.8	1/125 sec f/2.8	1/250 sec f/4	1/500 sec f/5.6
Interiors with bright fluorescent light √	1/15 sec f/2	1/30 sec f/2	1/30 sec f/2.8	1/30 sec f/4	1/60 sec f/5.6	1/60 sec f/11
School—stage and auditorium	—	—	—	1/15 sec f/2	1/30 sec f/2	1/60 sec f/2.8
Swimming pool—tungsten light indoors° (above water)	—	—	1/15 sec f/2	1/15 sec f/2	1/60 sec f/2.8	1/125 sec f/4
Hospital nurseries	1/15 sec f/2	1/15 sec f/2	1/30 sec f/2	1/30 sec f/2.8	1/60 sec f/4	1/125 sec f/5.6
Church interiors—tungsten light	1 sec f/2.8	1 sec f/4	1 sec f/5.6	1/15 sec f/2	1/30 sec f/2.8	1/60 sec f/4
Stained-glass windows, daytime—photographed from inside	Use 3 stops more exposure than for the outdoor lighting conditions.					
Glassware in windows, daytime—photographed from inside	Use 1 stop more exposure than for the outdoor lighting conditions.					

Note: The suggested exposures are approximate. For important pictures, bracket at least 1 stop on either side of the exposure in the table.

For color slides of these scenes, use tungsten or Type A film for the most natural rendition. You can also use daylight color film, but your slides will look yellow-red.

For color slides of these scenes, use daylight film. You can also use tungsten film with a No. 85B filter, or Type A film with a No. 85 filter over your camera lens. When you use either of these filters, give 1 stop more exposure than that recommended for daylight film in the table.

For color slides of these scenes, you can use daylight, tungsten, or Type A film. Daylight film will produce colors with a warmer, more yellowish look. Tungsten or Type A film produces colors with a colder, more bluish appearance.

For color prints, you can take pictures with KODAK GOLD Films of all the scenes listed in the tables and get acceptable color quality.

Use a tripod or other firm support for shutter speeds slower than 1/30 second.

§ If f/32 is not on your camera lens, use the next larger lens opening.

‖ When you want color slides and the lighting at these events is provided by Multi-Vapor lamps, you should get good results on daylight film. If the lighting is mercury-vapor, your slides will appear greenish. When the lighting is tungsten, you'll get better results with tungsten film.
Lighting provided by Multi-Vapor or mercury-vapor lamps—high-intensity discharge lamps—may cause uneven exposure in the picture or underexposure when you use shutter speeds higher than 1/125 second. This effect is unpredictable and depends on the lighting installation.

¶ Exposures are for the full moon unobscured. Since the moon will move during the exposure, don't include it in the picture or it will be blurred.

° When the lighting for these events is provided by tungsten lamps and you want color slides, you'll get better results by using tungsten film. If the lighting is Multi-Vapor, color rendition will be better on daylight film.

√ Use shutter speeds 1/60 second or longer with fluorescent light.

KODAK Films for Existing-Light Photography

Most of the color and black-and-white films Kodak manufactures for general use may be used successfully for existing-light photography. The following discussion will help you select the best ones for the types of scenes you photograph. Choice of filters, reciprocity effects, processing, and push processing with a variety of films are also covered.

Gerry Schoenherr

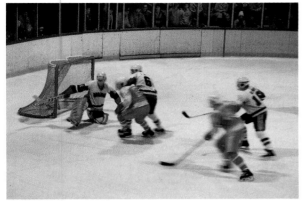
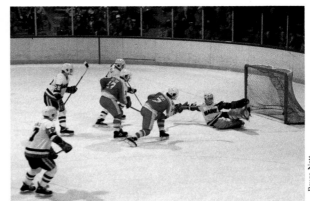

Bruce Nett

In existing light, picture sharpness may depend more on film speed than on film sharpness and resolving power. The photograph on the left was made on ISO 100-speed KODAK GOLD film, which has very high sharpness and high resolving power, 1/30 second at f/2.8. The photograph on the right was made on 1000-speed Kodak film, which has *medium sharpness and medium resolving power, and is inherently somewhat less sharp. Nonetheless, the picture made on ISO 1000-speed film looks sharper, because the much faster film allowed a higher shutter speed for better action stopping and a smaller aperture for more depth of field, 1/125 second at f/4.*

DEFINITION

Although you may be tempted to emphasize film speed above other qualities when you choose films for existing-light photography, you should also consider other important characteristics that affect definition. Definition is a composite effect of several factors including graininess, resolving power, and sharpness. These characteristics are related to film speed in ways that sometimes make it necessary to compromise in favor of one characteristic at the expense of another. Generally, Kodak films provide best definition when they're exposed correctly and processed according to recommendations.

You can use the descriptive definition ratings of graininess, resolving power, and sharpness that are provided for Kodak films to make comparisons within a class of films, such as color-negative films. These comparisons are valid. But you should not use these ratings to compare one class of films, such as black-and-white films, with another class, such as color-negative or color-slide films. Comparisons of definition between classes of films are not meaningful and can be misleading.

Graininess

Graininess is the textured or sandy effect that becomes apparent when an image is enlarged considerably. If you routinely make very large prints or project slides to extreme sizes, you are quite aware of the differences in graininess that exist among films. As a rule, the higher the film speed, the more pronounced a film's graininess will be. Relatively low-speed films have extremely fine grain that is difficult to detect even under extreme magnification. Very high-speed films reveal their grain at lower degrees of enlargement than slower films. Graininess also increases somewhat when films are push processed to permit exposure at higher than their rated film speeds.

If you expect to enlarge an image to a size that makes graininess noticeable, you should consider the trade-off between film speed and graininess. To minimize graininess, you may have to use a film with less speed, and therefore give up some motion-stopping ability or depth of field. Conversely, if you place a premium on stopping motion, gaining depth of field, or working with a hand-held camera, you need a film with higher speed. There are no universal solutions to these photographic considerations. Decide how you want the finished picture to look and choose accordingly. Graininess is usually not a concern in standard-album-size or smaller prints made from full-frame 35 mm negatives.

Resolving Power and Sharpness

Resolving power refers to the ability of a film or print to record fine detail. Resolving power is usually expressed in lines per millimetre and is determined by photographing a high-contrast parallel-line test chart at great reductions in size. Descriptive adjectives, such as high, medium, or low, are assigned to various resolving-power categories to make the measurements more meaningful in practical terms.

Film sharpness refers to the precision with which a film records hard-edged subject contours—the boundaries separating detail that is dark in a photograph and detail that is light. As a rule, and there are occasional exceptions, both resolving power and sharpness decrease somewhat as film speed increases.

When you work in low light with a hand-held camera, you are likely to produce sharper-looking pictures with high-speed films than with slower films, even though slower films are inherently sharper and have higher resolving power. The reason is that apparent picture sharpness is affected greatly by image motion and depth of field. In general, the more image motion is stopped and the greater the depth of field, the sharper the picture looks. The faster the film in your camera, the more likely you are to stop motion successfully and to have adequate depth of field. On the other hand, when you plan to photograph immobile subjects with a tripod-mounted camera, don't overlook the lower-speed films and their potential for producing extremely sharp results.

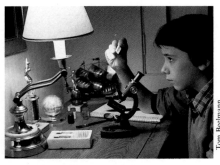

Tom Beelmann

You can expose high-speed color-negative films with many different light sources without corrective filtration because adequate color correction for noncritical use is done during printing. These pictures were made on 400-speed Kodak film with light from ordinary household lamps. The photo on the top was taken with no filter at 1/30 second at f/5.6. Color was balanced in printing. The photo on the bottom was taken with a No. 80A conversion filter at 1/15 second at f/4. Less color adjustment was required in printing and the balance is more accurate, but using the filter caused a 2-stop reduction in film speed. For most uses, the top version would be equally acceptable, although less fully corrected. Usually it's not practical to use camera filters in existing light because they absorb light and reduce effective film speed.

DX CODING

All popular Kodak 35 mm films and magazines have electronically readable codes known as DX coding. These codes enable 35 mm cameras with DX coding to sense the film speed and set the camera exposure system, sense exposure latitude of the film—for color-slide film or negative film—and sense the number of exposures automatically. Other codes help the photofinisher during processing and finishing. The codes are located on the film magazine and along the edges of the film. Film cartons and magazines for these films display the symbol "DX." Of course you can also use these films in 35 mm cameras that do not feature DX coding.

COLOR NEGATIVE FILMS FOR COLOR PRINTS

Color negative films record the subject in reverse tones and colors. The negative images of the processed film are projected onto photographic paper to produce positive color prints. You can also use color negatives to make color slides for projection or to make black-and-white prints. Kodak color negative films are balanced for correct color rendition with daylight-quality illumination. However, you can also expose them with a wide variety of other light sources and produce attractive color rendition in prints for noncritical applications, because color is adjusted during printing. When you require more precise color control, you can use correction filters over the camera lens to match the color quality of the image-forming light to the daylight balance of the film. The relatively wide exposure latitude of color negative films, particularly with regard to overexposure, helps them handle contrasty lighting with ease.

COLOR SLIDE FILMS

Also called color reversal transparency, or positive films, color slide materials, such as KODACHROME and KODAK EKTACHROME Films, produce full-color slides for projection or viewing on an illuminator. The film exposed in the camera becomes the final picture, or slide, after processing. You can have color prints made directly from your color slides or via a special intermediate color negative made from a slide, called an internegative. You can also have black-and-white prints made from a black-and-white or color internegative. And you can have duplicate color slides made directly from color slides or from an internegative.

Some color slide films are balanced for daylight and others are balanced for tungsten light sources. Gross mismatches of film and light source result in telltale color casts. Minor mismatches also result in color casts, but you'll frequently find that the results are acceptable. This is particularly true in existing-light photography, because you'll find it harder to perceive subtle color nuances in low light, and you may not remember exactly how the scene looked when you view your pictures later. Also, when you view slides projected in a darkened room, minor color discrepancies are less noticeable because of the absence of known-color cues in the room. In addition, as previously mentioned, the natural appearance of the existing lighting in the scene compensates to some extent for color rendition that's less than ideal. An example of this is a yellow-orange cast in photos of tungsten-lighted scenes photographed on daylight color film. For closely controlled color rendition, you can match both daylight and tungsten color films to many different light sources by using color filters over the camera lens if you can accept some loss in film speed from absorption of light by the filters.

As a group, color slide films have relatively narrow exposure latitude, with greater tolerance for mild underexposure than overexposure. It's usually better to have slightly more saturation with deep rich colors from slight underexposure than less saturation with washed-out colors from slight overexposure. Control of the lightness or darkness of color slides lies directly with the photographer, because no printing step is involved. Therefore, it is especially important to expose color slide film properly.

MATCHING COLOR FILMS TO ILLUMINATION

To obtain maximum color fidelity, scene illumination must match the light-source standard for which the film is balanced. Practically, this means selecting a film that matches the existing-light source in the scene. Even more practically, it means selecting a film that only *approximately* matches the existing-light source, since existing light is seldom exactly like the standard sources for which most color films are balanced. The closer the match, the more accurate the color rendition will be. You can balance image-forming light very precisely to film requirements when necessary by using color filters over the camera lens. Commercial photographic illustrators routinely use filters to achieve exact color effects.

In existing-light photography, however, which places a premium on preserving the mood of a scene, literal color rendition is generally less important than pleasing color rendition. For example, in a photograph of people gathered about a campfire, very warm, ruddy skin tones will be accepted as natural even though complexions appear far more orange than usual. In fact, fully corrected, conventional skin rendition in such a photograph would probably look unnatural and weaken the picture.

It's fortunate that total color correction is not always necessary for compelling existing-light photographs, because the low light levels discourage the use of the heavy filtration that you may need for literal color rendition. The following discussions of light sources and balancing them to color films illustrate this.

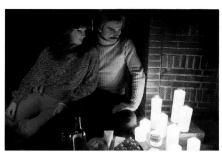 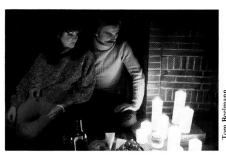

Tom Beelmann

Many existing-light pictures actually benefit by not being corrected to exact color rendition. The picture on the left, made on tungsten-balanced KODAK EKTACHROME 160 Film (Tungsten), conveys the feeling of the candlelight scene strongly because of the very warm *rendition. The picture on the right, made on the same film with a No. 80A filter to achieve nearly correct color balance, is much more accurate in its portrayal, but is less effective in evoking the mood of the moment.*

Color Temperature

When color films are described in terms of their suitability for use in daylight or tungsten light, you know the kinds of light sources for which they are balanced. However, you also know from everyday observation that the actual color quality of daylight varies enormously with time of day, weather conditions, geographic location, and other factors. And tungsten light includes such diverse sources as household bulbs, photolamps, auto headlights, and Christmas-tree lights. In fact, daylight and tungsten light are assigned specific values through measurements of color temperature and analysis of spectral energy distribution.

Daylight films produce conventionally correct color rendition when exposed under illumination with a color temperature of 5500 K. Tungsten films produce conventionally correct color rendition when exposed to illumination with a color temperature of either 3200 K or 3400 K, depending on the film. Kodak films designated as tungsten are balanced for 3200 K; Type A films are balanced for 3400 K. When film and light source match, color rendition is correct.

COLOR TEMPERATURES OF TYPICAL LIGHT SOURCES

Open shade	Approximately 12,000–18,000 K	Sunrise–sunset	3000–3100 K
Overcast sky	Approximately 7000 K	Photolamp	3400 K
Daylight— sunlight and skylight combined	5500 K	Tungsten photographic lamps	3200 K
Electronic flash	5500–6000 K	200-watt light bulb	2980 K
Carbon arcs	5000–5500 K	100-watt light bulb	2900 K
1 hour after sunrise, 1 hour before sunset	3500–3700 K	75-watt light bulb	2820 K
		Candlelight	1800 K

Color temperature is a standard means of describing the color of light by comparing it to the color of a reference object heated to various temperatures. Color temperature is expressed in Kelvin using degrees as the units of measure on a temperature scale used primarily in physics. Degree increments on the Kelvin scale represent the same temperature changes as degree increments on the Celsius scale. However, the Kelvin 0 point represents −273.16°C.

The key point to remember is that the higher the color temperature of a light source, the more blue-white it is. The lower the color temperature, the more red it looks. If you have ever seen an iron bar heated in a hot flame, you have witnessed a demonstration of changing color temperature. As the temperature rises, the bar changes slowly from deep red to white hot.

The great range of color temperatures spanned by these common light sources explains why a single film cannot provide correct color rendition under all shooting conditions without occasional corrective filtration. The variety of existing-light sources make it impractical for manufacturers to design a color film balanced precisely for each and every one. In practice, you should select the type of color film that most nearly matches the light sources you expect to encounter. Then for critical color rendition, use filters if you must to achieve the degree of color correction you feel necessary. Since it is seldom practical or desirable in existing-light photography to achieve full correction all the time, remember that most viewers are unlikely to notice color imbalances of up to approximately 200 K in pictures made under typical tungsten lights. Also, viewers are generally willing to accept greater imbalances as long as the pictures are logical and pleasing to them.

Minor imbalances are often unnoticed in existing-light photographs, especially when you view each photo separately and don't view pictures with different color balance side-by-side.

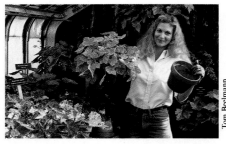

Converting tungsten-balanced color-slide films for use in daylight is more practical than filtering daylight films to match tungsten lighting. The daylight conversion filters for tungsten films absorb less light than the tungsten conversion filters for daylight films. Here an existing daylight scene is rendered well on KODAK EKTACHROME 160 Film (Tungsten) exposed through a No. 85B conversion filter with only a 2/3-stop loss in film speed.

DAYLIGHT ILLUMINATION

Daylight—including light coming through windows and skylights—carbon arcs, electronic flash, and moonlight are all good matches for daylight-balanced color films. Color variations associated with dawn or dusk or cool north light are usually best left uncorrected, since they help convey the mood and feeling of time and place. You can correct tungsten color-slide films balanced for 3200 K for use in daylight by placing a No. 85B amber conversion filter over the lens. This filter absorbs approximately 2/3 stop of light, in effect reducing the speed of the film by that amount. So, to compensate, increase exposure by 2/3 stop. To correct Type A color-slide films balanced for 3400 K for use in daylight, use a No. 85 amber conversion filter over the lens, and increase exposure by 2/3 stop. For example, you should expose KODAK EKTACHROME 160 Film (Tungsten), which has an ISO speed of 160 with no filter, at a speed of 100 when you use the No. 85B filter in daylight.

TUNGSTEN ILLUMINATION

Tungsten lighting provided by typical household incandescent bulbs is actually warmer, or more orange, than the 3200 K and 3400 K lights for which tungsten and Type A color-slide films, respectively, are balanced. However, the slightly warmer rendition this slight imbalance creates is generally attractive and desirable in existing-light photographs. If you need more accurate rendition, use a No. 82B light balancing filter, which absorbs 2/3

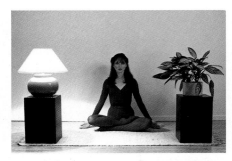

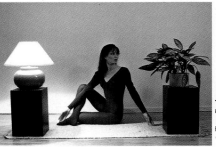

Photographs on unfiltered EKTACHROME 160 Film (Tungsten) balanced for 3200 K (top) yield slightly warm color balance when exposed with ordinary household tungsten light bulbs. Exposing the film through a No. 82B light balancing filter (bottom) gives a more accurate, less warm rendition. For most existing-light applications, the unfiltered version is perfectly satisfactory. When color balance is critical, however, the more fully corrected version is preferable, despite the 2/3-stop loss in film speed with the filter.

stop of light, and corrects 2900 K tungsten household illumination to 3200 K balance for EKTACHROME 160 Film (Tungsten).

Correcting daylight films for use in tungsten light is possible but frequently not practical in existing light because the conversion filters absorb a large amount of light. The No. 80A blue filter that converts 3200 K light to daylight quality for daylight film requires a 2-stop exposure increase. The No. 80B blue filter that converts 3400 K light to daylight quality requires a 1 2/3-stop exposure increase. Using these filters would lower the effective film speed of EKTACHROME 400 Film (Daylight) to ISO 100 and 125, respectively, from the usual speed of ISO 400 in daylight. This wastes most of the film's sensitivity to light. It is better to use the appropriately balanced EKTACHROME 160 Film (Tungsten) with no filter in the same situations and make full use of the film's speed of ISO 160.

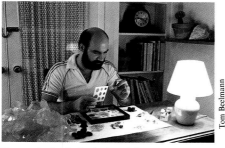

Tom Beelmann

Exposing daylight-balanced 400-speed film in household tungsten illumination with no filter (top) produced too warm a rendition for some viewers. Using a No. 80C conversion filter significantly reduced the excess warmth (center) and only caused a 1-stop loss of film speed. Full correction with a No. 80A conversion filter (bottom) resulted in a 2-stop film-speed reduction. This would be too much color correction for some viewers since tungsten lighting appears warm in actual scenes.

When the orange cast of uncorrected daylight color film in tungsten lighting is too much for subject or circumstances but full correction would mean too much loss of film speed, you can often compromise between color correction and film speed by making a partial correction. With daylight film in tungsten light, you can use a No. 80C blue conversion filter, which produces a moderately warm rendition that many viewers find pleasing and requires an exposure increase of only 1 stop. Partial correction may be preferable to a neutral, fully corrected rendition made with a darker filter, such as a No. 80A filter, that results in a larger loss in film speed.

Using One Film for Daylight and Tungsten Light Sources

If, for convenience, you want to use a single color-slide film for indoor and outdoor use, an artificial-light film with sufficient speed, such as KODAK EKTACHROME 160 Film (Tungsten), is a logical choice. Under tungsten lighting, it requires no filters and offers adequate speed for hand-held photography in many existing-light situations both indoors and outdoors at night. You can also use this film for subjects indoors in existing daylight and outdoors in daylight with a No. 85B filter. The film still has enough speed for all-around use in average or bright daylight outdoors, and lets you use action-stopping shutter speeds or small lens openings when you need depth of field. EKTACHROME 160 Film (Tungsten) is a good film to choose when you want to take color slides in existing tungsten light and outdoors in the daytime on the same roll of film.

FLUORESCENT ILLUMINATION

Fluorescent lights are good for photography in some respects, but cause problems, too, when you want to take pictures in color. Since fluorescent lights are commonly installed in multiple ceiling fixtures indoors in public places and work places, they provide relatively bright, even interior lighting. Fluorescent light is fine for black-and-white photographs, generally creating soft, unobtrusive shadows, although the lighting direction from overhead is not very flattering for photographing people. Usually, the light level is high enough for hand-held photography with fast black-and-white or color film if you have a fast enough lens.

Fluorescent illumination does cause color-rendition problems in color photographs. Because fluorescent lamps are deficient or completely lacking in certain wavelengths and have an excess of other wavelengths of the visible spectrum, you cannot correct them as accurately as other light sources, such as tungsten lamps. Generally, daylight color films produce more acceptable results in fluorescent illumination than tungsten films when you don't use any camera filtration. Pictures will usually have a yellow-green cast depending on the kind of fluorescent lamps in use. Tungsten film used without camera filters usually has a pronounced bluish cast.

Tom Beelmann

When you want to take color slides in fluorescent lighting, filters are usually required to produce reasonably good, natural colors. Without corrective filtration, daylight-balanced films generally produce better results than tungsten films. If you can use prints rather than slides, in fluorescent lighting you're better off using a color negative film, which can be filtered effectively during printing. As these fluorescent-light photographs show, unfiltered 200-speed slide film (top) produces somewhat yellow-green results. The same film produces reasonably natural rendition when exposed through CC40C + CC40M filters (center).

Tom Beelmann

An unfiltered color-negative film (above) will produce good color quality with printing corrections alone, or you can use filters over the camera lens for greater color fidelity.

FILTERS FOR FLUORESCENT LIGHT AND HIGH-INTENSITY DISCHARGE LAMPS

Type of Lamp	KODAK Color Film				
	All Color Negative Film	KODACHROME 64 (Daylight)	KODACHROME 200 (Daylight)	KODACHROME 25; EKTACHROME (Daylight)	EKTACHROME 160T (Tungsten)

Fluorescent Lamp

Type of Lamp	All Color Negative Film	KODACHROME 64 (Daylight)	KODACHROME 200 (Daylight)	KODACHROME 25; EKTACHROME (Daylight)	EKTACHROME 160T (Tungsten)
Daylight	40R + $^2/_3$ stop	45R + 10M + 1$^1/_3$ stops	30R + $^2/_3$ stop	50R + 1 stop	No. 85B + 40M + 30Y + 1$^2/_3$ stops
White	20C + 30M + 1 stop	05C + 40M + 1 stop	15B + 05M + 1 stop	40M + $^2/_3$ stop	50R + 10M + 1$^1/_3$ stops
Warm White	40B + 1 stop	25B + 20M + 1$^1/_3$ stops	35B + 05C + 1$^1/_3$ stops	20C + 40M + 1 stop	50M + 40Y + 1 stop
Warm White Deluxe	30B + 30C + 1$^1/_3$ stops	40B + 05C + 1$^1/_3$ stops	10B + 45C + 1$^1/_3$ stops	30B + 30C + 1$^1/_3$ stops	10R + $^1/_3$ stop
Cool White	30M + $^2/_3$ stop	15R + 30M + 1$^1/_3$ stops	20M + $^1/_2$ stop	40M + 10Y + 1 stop	60R + 1$^1/_3$ stops
Cool White Deluxe	20C + 10M + $^2/_3$ stop	05B + 10M + $^2/_3$ stop	05B + 20C + $^2/_3$ stop	20C + 10M + $^2/_3$ stop	20M + 40Y + $^2/_3$ stop
Unknown Fluorescent*	10C + 20M + $^2/_3$ stop	05C + 30M + 1 stop	10B + 05C + $^2/_3$ stop	30M + $^2/_3$ stop	50R + 1 stop

High-Intensity Discharge Lamp

Type of Lamp	All Color Negative Film	KODACHROME 64 (Daylight)	KODACHROME 200 (Daylight)	KODACHROME 25; EKTACHROME (Daylight)	EKTACHROME 160T (Tungsten)
General Electric Lucalox†	70B + 50C + 3 stops	70B + 50C + 2$^2/_3$ stops	50B + 70C + 2$^2/_3$ stops	80B + 20C + 2$^1/_3$ stops	50M + 20C + 1 stop
General Electric Multi-Vapor	10R + 20M + $^2/_3$ stop	30R + 15M + 1$^1/_3$ stops	20R + 15M + 1 stop	20R + 20M + $^2/_3$ stop	60R + 20Y + 1$^2/_3$ stops
Deluxe White Mercury	20R + 20M + $^2/_3$ stop	30R + 30M + 1$^1/_3$ stops	10R + 25M + 1 stop	30R + 30M + 1$^1/_3$ stops	70R + 10Y + 1$^2/_3$ stops
Clear Mercury	80R + 1$^2/_3$ stops	120R + 20M§ + 3 stops	110R + 10M§ + 2$^2/_3$ stops	70R‡ + 1$^1/_3$ stops	90R + 40Y + 2 stops

Note: The filters in the table are KODAK Color Compensating Filters (CC). Increase exposure by the amount shown in the table. Do not use sodium-vapor lamps for critical applications. Red filters have been substituted for equivalent values in magenta and yellow, and blue filters have been substituted for equivalent values in cyan and magenta. These substitutions were made to reduce the number of filters or to keep the exposure adjustment to a minimum (or both).

*When you don't know the type of fluorescent lamp, try the filter and exposure adjustment given; color rendition will be less than optimum.

†This is a high-pressure sodium-vapor lamp. The information in the table may not apply to other manufacturers' high-pressure sodium-vapor lamps because of differences in spectral characteristics.

‡For EKTACHROME 400 Film (Daylight) and EKTACHROME P1600 Professional Film (Daylight), use 25M + 40Y and increase exposure by 1 stop.

§This combination includes 4 filters; it is an exception to our recommendation of using a maximum of 3 filters.

The table above tells what color filtration to use with Kodak films under different types of fluorescent lighting. It assumes that relatively accurate color rendition outweighs the loss of light and film speed and the inconvenience of using strong filtration. For critical color control, make exposure tests to determine if further fine-tuning of the filter pack is necessary. If you don't know the type of fluorescent tubes illuminating the scene, use the "unknown" filter recommendations in the table; they provide generally acceptable color rendition for noncritical applications.

Because of the additional opportunities to make color corrections in printing, color negative films, particularly high-speed films, are the better choices for use in fluorescent lighting when you want color prints. Also, the tolerance of these films for light-source color variation usually produces acceptable results in fluorescent light. Whenever you use any film in fluorescent light, use shutter speeds longer than 1/60 second to avoid uneven exposure within the frame and underexposure. This is necessary because fluorescent lights do not emit light steadily; they actually flicker rapidly in time with pulses of alternating current. This flicker is not apparent to the eye but it is to the camera and film.

HIGH-INTENSITY DISCHARGE LAMPS
Typical high-intensity discharge lamps include Lucalox, Multi-Vapor, deluxe white mercury, clear mercury, and sodi-um-vapor lamps. They are often found in sports stadiums and arenas, in commercial and industrial environments, along streets and highways, and in parking lots. The table above gives the filtration required to produce acceptable color rendition with these light sources. In some cases, the filters will make handheld existing-light photography impractical because of the reduction of film speed.

The filter table for high-intensity discharge lamps is helpful if you know the type of lamps in use, but in most cases you won't know this and will have to make an educated guess.

Fortunately, for noncritical needs, we can categorize these lamps into three general types that you can identify by their appearance and where they're used.

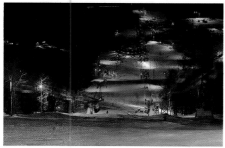

Mercury-vapor lamps on ski slope,
KODACHROME 64 Film (Daylight),
no filter.

John Vaeth

Bruce Nett

Sodium-vapor lamps, 200-speed daylight-
balanced film (top), no filter, natural
appearance of scene with yellowish cast.
160-speed tungsten-balanced film (bot-
tom), no filter, a more neutral rendition
than the daylight-film version.

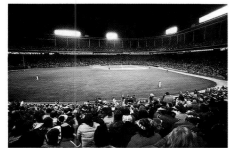

Kevin Twombly

Multi-Vapor lamps, 200-speed daylight-
balanced film, no filter.

Mercury-vapor lamps are generally used for outdoor lighting for highways, streets, and parking lots. This type of lighting may also be used for small, non-professional playing fields for sports. These lamps usually have a slight bluish-green appearance. For noncritical purposes, you can use daylight films without filters. Color slides will be somewhat blue-green, but should be acceptable. Since KODAK GOLD Films have more tolerance for color variations among light sources, they are easier to use than color-slide films.

Sodium-vapor lamps are usually used for the same outdoor night lighting as mercury-vapor lamps. But it's easy to distinguish between the two kinds because sodium-vapor lamps have a distinctive yellowish-amber appearance. Since these lamps are not recommended for critical photo needs, we do not give camera filter recommendations. However, you can obtain acceptable results for noncritical applications by using tungsten or Type A films for color slides without using camera filters. If you use daylight color films, color rendition will be yellowish and less than ideal, but this is usually tolerable for existing-light photographs because that's the way the light sources and scene appear. Of course, you can always take pictures with black-and-white film to avoid color-rendition problems.

Multi-Vapor lamps are often used in sports stadiums and indoor sports arenas. These lamps emit light of good color quality for photography. If color isn't

These three views show the lighting
produced by the three general types of
high-intensity discharge lamps—mercury-
vapor, sodium-vapor, and Multi-Vapor
lamps. Mercury-vapor and sodium-vapor
lamps emit light of such odd color quality
that even optimum filtration may not
achieve natural rendition in pictures for
critical use. Multi-Vapor lamps emit light
that's more like daylight in color quality
and that's better for photography. An
added complication with these light
sources is that you can't always find out
the types of lamps in use. For noncritical
needs, use daylight color-slide film
without camera filters for mercury-vapor
and Multi-Vapor lamps and tungsten or
Type A color-slide films without filters
for sodium-vapor lamps. KODAK GOLD
Films without filters give acceptable color
prints for noncritical purposes with all
three light sources.

critical, you can use daylight color-slide films without camera filters and get good color rendition. Multi-Vapor lamps have been installed to illuminate many sports activities because the lighting must be suitable for color telecasts and photography. You can recognize this lighting by its more neutral-white appearance compared with the slightly blue-green appearance of mercury-vapor lighting.

All three types of high-intensity lamps are used for indoor commercial and industrial lighting. In these locations, you may be able to contact the maintenance personnel to ask them what kind of lamps are in use. Generally, color rendition is somewhat more critical in indoor existing-light photographs than in those taken outdoors at night.

In some older facilities or in smaller interior areas, you may find ordinary tungsten incandescent lamps that require tungsten or Type A color-slide films for good color rendition. These tungsten lamps are the same as or similar to those used in home lighting. They are not as bright and have a slight yellowish appearance compared with mercury-vapor and Multi-Vapor lamps, and a more neutral appearance compared with sodium-vapor lamps.

When you want color prints of scenes illuminated by high-intensity discharge lamps, the task is easier, because you can use color negative film and benefit from color corrections that can be made in printing. However, the printing procedure may not be able to correct the color completely.

When you use high shutter speeds with high-intensity discharge lamps, such as for stop-action sports photography, you may get streaks or underexposure effects. This is caused by the interaction of the camera shutter with the pulsing of the lamps from the 60-cycle electrical current; this pulsing is not noticeable to the eye. The effects of pulsing are most noticeable at shutter speeds higher than 1/125 second, but are unpredictable. They depend on many factors associated with the lighting installation and can vary widely. Your pictures may or may not be spoiled by it. There is less of a problem with sports stadiums or arenas that have a large number of lamps providing even illumination for the sports event.

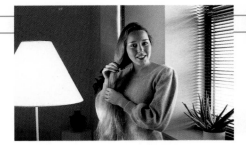
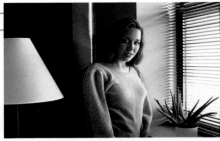

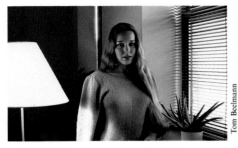

MIXED LIGHT SOURCES

Existing-light scenes are sometimes illuminated by several light sources of different and incompatible color quality. For example, a person might be illuminated on one side by daylight streaming through a window and on the other by tungsten light from household lamps or fluorescent light from ceiling fixtures. Balancing the film to one light source makes it incompatible with the other. There are several ways to handle this. If you want color prints, it's easiest to use a color-negative film and balance the color during printing for the most pleasing photograph. If you use color-slide film, choose one of the following approaches to fit the situation.

Many outdoor night scenes, especially street scenes, are illuminated by light sources of different colors. These situations are handled differently from indoor scenes with mixed lighting and are discussed on page 53 under "Potpourri Lighting."

Eliminate Unwanted Illumination

A simple way to deal with multiple light sources of different color quality is to eliminate the ones you don't want, if possible. In the window-light situation above, you could turn off the tungsten lights and make the picture on daylight film, or you might close the curtains and move the person away from the window and use only tungsten light to take the picture on tungsten film.

Choose the Dominant Source

If one light source is noticeably stronger or more widespread than another, choose film or filtration for the dominant source. Then compose the picture to exclude areas illuminated by secondary light sources as much as you can.

Mixed Lighting of Equal Proportions

Sometimes the different light sources are equally strong and affect roughly equal areas of the scene. If you balance to daylight, tungsten-lighted subject matter will be rendered very warm, or yellow-orange. If you balance to tungsten, daylighted subject matter will be rendered very cool, or coldly blue. Decide how you want the picture to look and proceed accordingly. When skin tone is involved, the warmer rendition will usually be preferable.

When a subject is illuminated by both daylight and tungsten light, one solution is to take the picture on daylight film without a filter. In the top left photo, EKTACHROME 200 Film (Daylight) rendered daylighted areas well, but tungsten-lighted areas look too warm. Many people find this result acceptable, though, because that's the way the scene appeared. In addition, the tungsten light filled in the shadow side of the subject. Switching to EKTACHROME 160 Film (Tungsten) yielded good color in tungsten-lighted areas, but daylighted areas look too blue (bottom left photo); most people find this unacceptable. With a color imbalance, it's usually better to have a warm balance rather than a cold one.

If you find the first photo unacceptable (top left) or want more accurate color rendition, you can eliminate or minimize one light source, then choose a film balanced for the other illumination. On the top right, turning off the room lights and working solely by window light gave pleasing color rendition with EKTACHROME 200 Film (Daylight). The shadow side of the subject, though, is now darker because the room lights are off and aren't providing any fill light. You could either change the camera angle to photograph the subject more from the window side to minimize shadow areas or use a reflector to fill in the shadows. See page 64. Good color rendition in the last photo resulted from closing the drapes, moving the subject deeper into the tungsten-lighted room, and using EKTACHROME 160T Film (Tungsten). This, however, has altered the original composition of the scene.

When the subject is a person and the choice is between a warm color balance made on EKTACHROME 200 Film (Daylight) (left) and a cold one made on

EKTACHROME 160 Film (Tungsten) (right), most people prefer the warm picture. The lighting for this scene was a mixture of fluorescent and tungsten light.

Paul Kuzniar

Photograph scenes that contain a mixture of light sources on the film type that will produce a color rendition you like. A daylight-balanced film, such as EKTACHROME 400 Film (Daylight) (top), yields a warmer rendition than a tungsten-balanced film, such as EKTACHROME 160 Film (Tungsten) (bottom).

The Skin-Tone Factor

Although preferences in color balance are very much a matter of personal taste, most viewers agree broadly about one thing: Where skin-tone rendition is concerned and color rendition is less than ideal, warm, yellow-orange rendition is better and more pleasing than cold rendition. Whenever people are prominent in the picture, avoid excessively cold, bluish rendition, because it makes people look cadaverous. If you cannot achieve perfect color balance, err on the side of warmth and you'll nearly always be safe.

Potpourri Lighting

Some existing-light subjects contain so many different light sources of such varied color quality that the concept of "correct color balance" just doesn't apply. A carnival midway or a cityscape at night, for example, can easily boast an array of lights ranging in color quality from daylight during twilight and day-light-quality carbon-arc spotlights through candlelight, from blue-white to cherry red. Just remember that daylight film will render the scene more warmly and tungsten film will render it more coldly. Neither choice is better except in terms of making the picture look the way you want it to. If you prefer a warm rendition, daylight film is better. If you prefer a colder rendition, tungsten film is better.

USING FILTERS

The colored filters commonly used to balance image-forming light to match film type, adjust color for effect, or fine-tune it subtly all share one basic characteristic: They absorb light. Filters work their magic not by adding their own color to the light reaching the film but rather by subtracting light of the complementary color. Color filters always prevent some light from entering the camera. Consequently, whenever you use colored filters, you have to increase exposure to compensate for the light the filter absorbs. The tables that follow give exposure corrections for conversion, light-balancing, and KODAK Color Compensating Filters. These filters are sold by photo dealers.

In the low light levels that you work with in existing-light photography, there is not much tolerance for additional loss of light, so avoid heavy filtration when possible. When you foresee a need for strong filtration, choose the fastest suitable film and consider pushing the film speed, too, if possible. This helps to permit using a small enough lens opening for good depth of field or a fast enough shutter speed for hand-holding your camera or for stopping action.

Many through-the-lens exposure meters can compensate accurately for light absorbed and transmitted by color filters. Some cannot. And many non-SLR cameras have meter cells that do not read through lens attachments. If your camera exposure meter cannot correct automatically for filters, do this: Set the camera film-speed dial for the speed of the film without a filter, and make the meter

CONVERSION FILTERS

To Convert	Use Filter Number	Filter Color	Exposure Increase in Stops*
3200 K to Daylight 5500 K	80A		2
3400 K to Daylight 5500 K	80B	Blue	1 2/3
3800 K to Daylight 5500 K	80C		1
4200 K to Daylight 5500 K	80D		1/3
Daylight 5500 K to 3800 K	85C		1/3
Daylight 5500 K to 3400 K	85	Amber	2/3
Daylight 5500 K to 3200 K	85B		2/3

*These values are approximate. For critical work, run tests, especially if you use more than one filter.

LIGHT-BALANCING FILTERS

To Obtain 3200 K from:	To Obtain 3400 K from:	Use Filter Number	Filter Color	Exposure Increase in Stops*
2490 K	2610 K	82C + 82C		1 1/3
2570 K	2700 K	82C + 82B		1 1/3
2650 K	2780 K	82C + 82A		1
2720 K	2870 K	82C + 82		1
2800 K	2950 K	82C	Bluish	2/3
2900 K	3060 K	82B		2/3
3000 K	3180 K	82A		1/3
3100 K	3290 K	82		1/3
3200 K	3400 K	No Filter Necessary	—	—
3300 K	3510 K	81		1/3
3400 K	3630 K	81A		1/3
3500 K	3740 K	81B		1/3
3600 K	3850 K	81C	Yellowish	1/3
3700 K	3970 K	81D		2/3
3850 K	4140 K	81EF		2/3

*These values are approximate. For critical work, run tests, especially if you use more than one filter.

KODAK COLOR COMPENSATING FILTERS

Nominal Peak Density	Yellow (Absorbs Blue)	Exposure Increase (Stops*)	Magenta (Absorbs Green)	Exposure Increase (Stops*)	Cyan (Absorbs Red)	Exposure Increase (Stops*)
0.025	CC025Y	—	CC025M	—	CC025C	—
0.05	CC05Y	—	CC05M	1/3	CC05C	1/3
0.10	CC10Y	—	CC10M	1/3	CC10C	1/3
0.20	CC20Y	1/3	CC20M	1/3	CC20C	1/3
0.30	CC30Y	1/3	CC30M	2/3	CC30C	2/3
0.40	CC40Y	1/3	CC40M	2/3	CC40C	2/3
0.50	CC50Y	2/3	CC50M	2/3	CC50C	1

Nominal Peak Density	Red (Absorbs Blue and Green)	Exposure Increase (Stops*)	Green (Absorbs Blue and Red)	Exposure Increase (Stops*)	Blue (Absorbs Red and Green)	Exposure Increase (Stops*)
0.025	CC025R	—	CC025G	—	CC025B	—
0.05	CC05R	1/3	CC05G	1/3	CC05B	1/3
0.10	CC10R	1/3	CC10G	1/3	CC10B	1/3
0.20	CC20R	1/3	CC20G	1/3	CC20B	2/3
0.30	CC30R	2/3	CC30G	2/3	CC30B	2/3
0.40	CC40R	2/3	CC40G	2/3	CC40B	1
0.50	CC50R	1	CC50G	1	CC50B	1 1/3

*These values are approximate. For critical work, run tests, especially if you use more than one filter.

Color-compensating filters are normally used to effect relatively small changes in color rendition. Light-balancing filters effect moderate shifts in color balance and are most often used to correct light of nonstandard color temperature to either 3200 K or 3400 K. Conversion filters produce substantial changes in the color temperature needed to match standard artificial light sources to daylight films or to match daylight to films balanced for artificial light. You can also use all of these filter types to create imaginative, offbeat color effects.

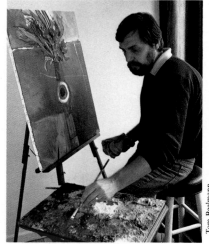

Tungsten-balanced film, no filter

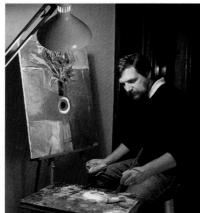

Tungsten-balanced color slide film exposed in daylight without corrective filtration causes a blue cast, while daylight-balanced film exposed to tungsten light without correction yields a yellow-orange cast.

Daylight-balanced film, no filter

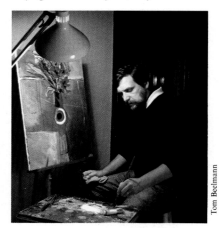

Daylight-balanced film, no filter

Daylight Illumination

Tungsten-balanced film, no filter

Tungsten Illumination

Tom Beelmann

Tom Beelmann

reading without the filter. Find the exposure increase for the filter in one of the filter tables or in the film or filter instructions, and adjust the exposure setting *manually* to compensate for the filter. Then place the filter over the lens and take the picture.

You can determine if your exposure meter makes correct readings through color filters. First set the film-speed dial for the speed of your film without a filter. Then make a meter reading *through* the filter and note the camera settings. Then calculate the exposure by using the filter tables described in the preceding paragraph. If the camera settings are the same, the meter reading through that particular filter is reliable. When the through-the-lens meter reading compensates correctly for the light absorbed by the filter, set the speed of the film without a filter on the film-speed dial of your camera or meter.

RECIPROCITY EFFECTS AND COMPENSATION FOR COLOR FILMS

In photography, the law of reciprocity states that brief exposure to much light should produce the same effect on film as a proportionately longer exposure to less light. For example, an exposure of 1/8 second at $f/1.4$ should produce the same effect as a 16-second exposure at $f/16$. In fact, the law of reciprocity does not hold true at extremely short or long exposure times. With color films, failure of the law of reciprocity at longer-than-normal exposure times manifests itself as underexposure and produces color-cast changes from normal color rendition, since each color layer in the film emulsion may be affected differently. The reciprocity effects of extremely short exposure times usually don't apply to existing-light photography.

In practice, the nonstandard color quality in many existing-light scenes tends to mask small to moderate deviations in exposure and color rendition. As a rule, it is better to avoid reciprocity effects than to have to correct them. If you can, use a fast film that will let you work at shutter speeds short enough to avoid the problem.

PROCESSING *KODAK* COLOR FILMS

Have your film processed promptly after exposure. You can return Kodak film to your photo dealer for processing, or you can process KODAK GOLD, KODAK ROYAL GOLD, and KODAK EKTACHROME Films yourself.

You cannot process KODACHROME Film successfully in your own darkroom; the process is complex and requires commercial photofinishing equipment.

After your film is processed, you can have prints made through your photo dealer or you can make them yourself in your own darkroom. You can have duplicates made of your slides or transparencies, or have color slides made from your color negatives or color prints. It's also possible to have color negatives made from color prints or slides.

If you want black-and-white prints from color negatives, you can make them on KODAK PANALURE Papers, which are specially designed for printing color negatives. To make black-and-white prints from color slides, you'll need to make a black-and-white negative from each slide first. Some processing labs also make black-and-white prints from color negatives or slides.

If you have questions about making your own color prints, you can purchase books such as Publication R-19, *KODAK Color Darkroom DATAGUIDE* and Publication AE-13, *Basic Developing, Printing, Enlarging in Color* from your photo dealer or bookstore.

Push Processing
KODAK EKTACHROME Films

As noted earlier, when you need more film speed than the standard speed rating provides, you can obtain good results with KODAK EKTACHROME Films by doubling the ISO speed and push processing the film by extending the development time. The table on page 56 shows how to increase the first developer time when you push process KODAK EKTACHROME Films in KODAK Chemicals, Process E-6, to double the standard film speed or, for emergency

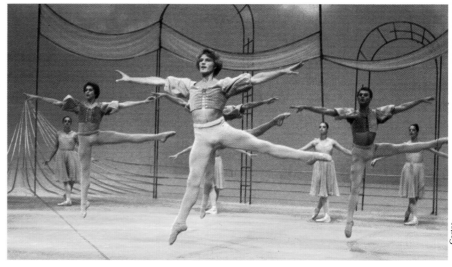

Push-processing KODAK EKTACHROME Films allows you to double or quadruple the film speed to stop action with higher shutter speeds or to obtain greater depth of field by using smaller lens openings in existing light. This picture was photo-graphed on EKTACHROME 160 Film (Tungsten) rated at ISO 320 and push-processed by 1 stop. 'Allegro Brillante,' starring Peter Martins, courtesy New York City Ballet.

use, to quadruple the standard speed. Changes in graininess and contrast that occur when you double the film speed probably won't be noticed in most existing-light applications. Increased graininess and contrast that result from pushing to four times the normal ISO speed are more noticeable but usually aren't objectionable for noncritical purposes for low-light subjects.

For optimum picture quality, it is better to expose a high-speed film at its normal speed (the speed it's designed for) than to push a film with less speed to a higher speed. And remember that push processing affects an entire roll of film. You cannot push process only part of a roll because it's impractical to separate exposures that require longer development times from those needing only normal processing. To avoid mix-ups that could spoil pictures, prominently mark containers of exposed film that require push processing with the notice: PUSH TO 800 (or applicable speed number). Keep these containers separate from film that you want to have processed normally. Be sure to reset the film-speed dial on your camera or handheld exposure meter to the normal speed value when you've finished exposing a roll at a boosted film speed. It will help reduce the likelihood of inadvertently underexposing your next roll if you forget to check the film speed setting on the meter dial.

KODAK EKTACHROME P1600 Professional Film (Daylight) is optimized for use at EI 1600, with 2-stop push processing. Under adverse condi-

tions you can push process the film to EI 3200, but you will obtain a loss in quality; you obtain better quality at EI 1600. Film speeds are printed on the film magazine, which has a surface that you can write on. Circle the push processing speed you want.

55

PROCESS ADJUSTMENTS FOR *KODAK EKTACHROME* FILMS

KODAK EKTACHROME Film					KODAK EKTACHROME Film Processing Kit	
P1600 Professional	400	200	160T	100	Change First-Developer Time by (min:sec)	Change Temperature by
	Film Speed (ISO or EI)				OR	
–	200	100	80	50	– 2:00	– 6°F (3.3°C)
–	200	160	100	100	No change	No change
–	800	400	320	200	+ 2:00	+ 8°F (4.4°C)
1600	1600	800	640	400	+ 5:00	+ 12°F (6.7°C)
3200	–	–	–	–	+ 7:30	+ 16°F (8.9°C)

Special Processing for Increased Speed

When lighting conditions are dim, as they are in many existing-light scenes, you may need higher film speed for hand-holding your camera, stopping action, using a telephoto lens, or using a small lens opening to gain depth of field. You can increase the speed of KODAK EKTACHROME Films by obtaining special processing from a processing lab, or by extending the first-developer time if you process the film yourself.

KODAK EKTACHROME P1600 Professional Film is designed for push processing to attain its very high speed. If you want to process the film yourself to increase film speed, simply increase the normal first-development time by the amount given in the table. For all other steps, follow the normal processing times given in the instructions that come with the chemicals. When you process your own films, you can change their effective speeds over a wide range, as shown in the table. Exposing and processing the film at speeds other than the normal EI 1600 will result in some loss of photographic quality. The more you vary the speed from normal, the greater the reduction in quality.

KODAK BLACK-AND-WHITE FILMS FOR EXISTING LIGHT

Although human eyes perceive a world of color, some of the most compelling photographs ever made have been made in black-and-white. For the existing-light photographer, high-speed black-and-white films, such as KODAK T-MAX 400 Professional and TRI-X Pan Films, facilitate working in low light of uncertain color quality. Most of the Kodak black-and-white films suitable for existing-light photography with a hand-held camera are inherently fast films.

If the lighting is extremely poor, or if you want to stop fast action or use telephoto lenses, you may need an even faster film, such as KODAK T-MAX P3200 Professional Film. It is a multi-speed film that combines high to ultra-high speed with finer grain than that of any other fast black-and-white films.

The broad exposure latitude of many popular black-and-white films allows you to capture contrasty and unevenly lighted scenes that defy optimum rendition on color-slide materials, which have a narrow latitude. Black-and-white films generally have more latitude for overexposure than for underexposure. Excessive overexposure will lead to loss of definition and increased graininess.

For practical purposes, you can ignore concerns about the color quality of ambient light. And if you need an even higher film speed than the film provides with normal processing, you can easily push most high-speed black-and-white films so you can expose them at two times the normal ISO speed—1 stop less exposure—with minimum loss of quality by taking advantage of the exposure latitude of the film. Or you can expose most high-speed black-and-white films at four times

the normal ISO speed—2 stops less exposure—with minimum loss of quality by push processing the film. When you push black-and-white film this way, you are not actually increasing the film speed significantly. See the discussion on page 59. Working in black and white offers an unparalleled opportunity to control the image through coordinated adjustments in exposure, processing, and printing.

KODAK T-MAX P3200 Professional Film

KODAK T-MAX P3200 Professional Film is a multi-speed film that combines high to ultra-high film speed with finer grain than that of other fast black-and-white films. This is an extraordinary film for existing-light photography. It is an excellent choice for indoor or nighttime sports events and available-light press photography, as well as law-enforcement and general surveillance applications that require exposure indexes of 3200 to 25,000.

The nominal speed is EI 1000 when the film is processed in KODAK T-MAX Developer, or EI 800 when it is processed in other Kodak continuous-tone black-and-white developers.

Because of its great latitude, you can expose this film at EI 1600 and yield negatives of high quality. When you need a higher speed, you can expose this film at EI 3200 or 6400 with an increase in contrast and granularity and a loss of shadow detail.

For general use, it's best to expose this film at EI 3200 or 6400. These speeds allow you to take photographs in many situations where photography was previously impossible. To expose film at speeds higher than EI 6400, run tests to determine if the results are satisfactory for your needs.

KODAK T-MAX 400 Professional Film

KODAK T-MAX 400 Professional Film also incorporates KODAK T-GRAIN Emulsions. It features both a high speed of EI 400 and superb definition with extremely fine grain and very high sharpness. The film also has expanded exposure latitude—a greater tolerance for exposure errors that gives quality prints from under- or overexposed negatives. It has an even tonal range with silky grays and powerful blacks and whites; spectral response more like that of the human eye for more realistic tonal rendition; and improved reciprocity characteristics for both long and short exposures.

You can use this film to photograph most existing-light subjects while hand-holding your camera if you have an *f*/2 or faster lens. In brighter existing lighting, you can use higher shutter speeds to stop action or a smaller lens opening to gain depth of field.

The film responds well to pushing when you need a higher exposure index under demanding conditions, e.g. when you need to stop fast action in low light levels. You can underexpose by 1 stop with normal processing or by 2 stops with push processing and obtain quality prints. See "Pushing Black-and-White Film" on page 58.

KODAK T-MAX 100 Professional Film can produce pictures with high sharpness and little perceptible graininess, even when greatly enlarged.

Bill Cafer

KODAK T-MAX 400 Professional Film combines high speed with extremely fine grain, which helps you obtain excellent- *quality photos with a hand-held camera in spontaneous existing-light situations.*

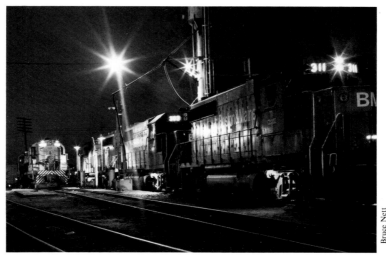

Bruce Nett

KODAK TRI-X Pan Film, with a speed of ISO 400, offers the existing-light photographer high film speed, excellent image quality, and complete freedom from *concerns about color balance. Some of the most dramatic and expressive existing-light photographs have been made in black-and-white.*

KODAK TRI-X Pan Film

For all-around existing-light photography, KODAK TRI-X Pan Film, ISO 400, offers the combination of high speed, fine grain, and very high sharpness, plus great exposure latitude. This film's excellent quality and versatility has made it the film of choice for photojournalists and sports photographers, regardless of light levels; these photographers must capture moving subjects in light ranging from desert glare to coal-bin murk.

KODAK T-MAX 100 Professional Film

This premier black-and-white film derives its outstanding characteristics from KODAK T-GRAIN Emulsions. With this state-of-the-art emulsion technology,

Kodak can make films finer-grained and sharper with higher definition *and* faster speeds. T-MAX 100 Film features extremely fine grain and extremely high sharpness with a medium speed of EI 100.

This film offers many of the same benefits as T-MAX 400 Film: expanded exposure latitude; more natural spectral response; rich, silvery tone reproduction; and improved reciprocity characteristics.

You can use this film to photograph existing-light subjects in higher light levels, such as existing daylight, when you don't require high film speed but do need high image quality for making big enlargements.

KODAK PLUS-X Pan Film

In bright existing light, KODAK PLUS-X Pan Film, ISO 125, combines adequate speed with extremely fine grain and sharpness great enough to permit making big, detailed enlargements. It has excellent exposure latitude, so it forgives exposure errors.

KODAK Technical Pan Film

KODAK Technical Pan Film, with a film speed of 25, features micro-fine grain and extremely high sharpness for excellent pictorial black-and-white image quality. Its amazing definition provides excellent enlargements at magnifications of 25X and even 50X. For pictorial uses, you should expose the film at EI 25 and develop it in a special low-contrast developer, such as KODAK TECHNIDOL Liquid Developer to achieve normal contrast and sufficient exposure latitude.

Use this film when you want to make big prints and can get by with the lower speed. To use it with a hand-held camera, the subject should be in very bright existing light, such as window light. Or you can mount your camera on a tripod for taking pictures in existing light of average brightness. For existing-light photography, this film is more adaptable to inanimate, stationary subjects for which you can use slow shutter speeds.

PROCESSING *KODAK* BLACK-AND-WHITE FILMS

There are several ways you can have your black-and-white film processed. If you have your own equipped darkroom, you're all set to be creative and enjoy processing and printing black-and-white film. If you're not experiencing the fun of doing your own darkroom work yet, you can take your film to a photo dealer for printing by a processing lab.

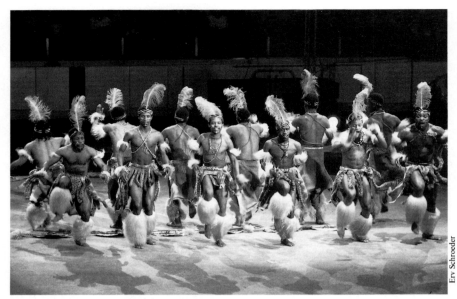

KODAK T-MAX P3200 Professional Film is a multi-speed film with finer grain than that of other fast black-and-white films. It is useful for hand-holding telephoto lenses for fast action or in dim light. Photo courtesy of Ringling Bros. and Barnum & Bailey Combined Shows, Inc.

Pushing Black-and-White Film

When the light is too low for exposing a black-and-white film at its normal ISO or EI rating, you can expose the film at a higher speed rating (underexpose it) and still obtain good results. This will often enable you to hand-hold your camera in very dim light, stop subject motion by using a higher shutter speed, or use a smaller lens opening to gain depth of field. When you underexpose the film by only 1 stop (use twice the normal speed rating), you can take advantage of the exposure latitude of the film and still process it normally; this works especially well with scenes that have low contrast with a short tonal range. When you underexpose the film by 2 or 3 stops (expose the film at 4 or 8 times the rated speed), you need to push-process the film by increasing the development time. See the table at the right.

You can use various developers to push-process KODAK T-MAX Professional Films and other Kodak black-and-white films, but we suggest you use KODAK T-MAX Developer or KODAK T-MAX RS Developer and Replenisher. These developers improve tone reproduction by enhancing shadow detail.

Push processing is most successful and gives very good results with scenes that have soft, even lighting rather than harsh, contrasty illumination. Moderately contrasty subjects will usually produce nearly normal-looking prints with push processing. However, there will be some loss of shadow detail.

Generally, for high-contrast scenes which have harsh lighting that produces brilliant highlights and deep black shadows, you should not underexpose the film by more than 1 stop; that is, do not use more than twice the rated speed. However, if detail in the deep-shadow areas is important to the scene, it is better to *over*expose the film by 2 stops and process it normally.

You will probably find that you push-process only the higher-speed films. If you need more speed than a lower-speed film can provide at its normal rating, it is easier and better to switch to a faster film. However, you can push process the slower black-and-white films if you run out of faster film or if you accidentally underexpose the film.

Remember that when the normal speed of a film is adequate for the pic-

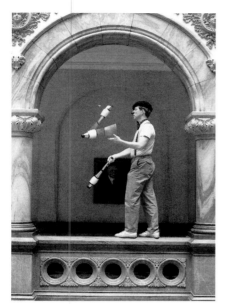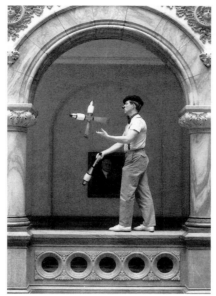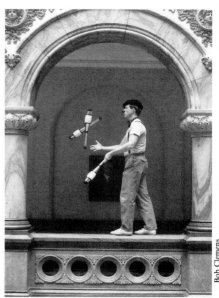

EI 400, 1/30 second, normal exposure, normal processsing in KODAK T-MAX Developer.

EI 800, 1/60 second, 1 stop less exposure than normal, normal processing in KODAK T-MAX Developer.

EI 1600, 1/125 second, two stops less exposure than normal, push-processed in KODAK T-MAX Developer with a 1/3 increase in development time.

Push-processing black-and-white films works best when scene contrast is low or average. The same lens opening was used for each picture at progressively higher shutter speeds. Scene contrast was average, and all three pictures are acceptable. The photo taken at the normal speed of the film, EI 400, displays the best image quality, while the pushed shots show progressive loss of quality, especially in shadow detail, as the film was exposed at higher exposures indexes. The higher shutter speeds permitted by the higher exposure indexes help eliminate subject motion without sacrificing depth of field. KODAK T-MAX 400 Professional Film processed in KODAK T-MAX Developer.

ture-taking conditions, you'll obtain the highest image quality when you expose and process your film normally. A push-processed black-and-white film will have less shadow detail and more graininess. However, this slight loss in quality may be acceptable when you need the benefits of added speed.

An important point to understand about push processing black-and-white negative films is that it doesn't significantly increase the speed of the film. Film speed, which is related to shadow detail, is inherent in the film; you cannot increase it significantly by merely extending the development time.

PUSH-PROCESSING *KODAK* BLACK-AND-WHITE FILMS IN A SMALL TANK*

KODAK Developer	Development Time (min:sec)†		
T-MAX 400 Professional			
	EI 800	EI 1600	EI 3200
T-MAX	6:00	8:00	9:30
D-76	8:00	10:30	NR
HC-110 (Dil B)	6:00	8:30	NR
TRI-X Pan			
	EI 800	EI 1600	EI 3200
T-MAX	5:30	8:00	11:00
D-76	8:00	13:00	NR
HC-110 (Dil B)	7:30	16:00	NR
T-MAX 100 Professional			
	EI 200	EI 400	EI 800
T-MAX	6:30	9:00	10:30
D-76	9:00	11:00	NR
HC-110 (Dil B)	7:00	9:30	NR

NR = Not recommended.

*Agitation at 30-second intervals.

†Times given for T-MAX Developer are for development at 75°F (24°C). All times for other developers are for 68°F (20°C).

Bob Clemens

RECIPROCITY EFFECTS FOR BLACK-AND-WHITE FILMS

Black-and-white film, like color film, behaves differently when exposed for unusually short or long times. Reciprocity effects in black-and-white film include apparent loss of speed and contrast changes. The table below suggests exposure increases and adjustments in developing times to correct reciprocity effects with most general-purpose Kodak black-and-white films.

In many existing-light settings, lighting and subject contrast tend to mask minor deviations from normal rendition, so you can ignore mild reciprocity effects. If you expect pronounced reciprocity effects, use the corrections in the table as starting points for tests to determine what exposure and development modifications work best. If you must mix normal exposures and very long ones on the same roll of film, do not apply the development adjustments listed in the table; they will adversely affect the normally exposed frames. Instead, adjust the exposure as indicated and develop the roll normally; then you can rely on contrast control in printing to produce a print that resembles the scene as you remember it.

As in existing-light color photography, the best way to deal with reciprocity effects in black-and-white is to avoid them by using film fast enough so you don't need excessively long exposure times.

This table suggests exposure and development adjustments for correcting reciprocity effects with Kodak general-purpose black-and-white films. If you must mix normal and long exposures on one roll of film, make the indicated exposure adjustments but develop the roll normally and control contrast as necessary when printing.

EXPOSURE AND DEVELOPMENT COMPENSATION FOR RECIPROCITY CHARACTERISTICS

KODAK Film	Exposure Time in Seconds	$\frac{1}{100,000}$	$\frac{1}{10,000}$	$\frac{1}{1000}$	$\frac{1}{100}$	$\frac{1}{10}$	1	10	100
T-MAX P3200 Professional	Increase Lens Opening by	—	None	None	None	None	None	2/3 stop	—
	Or Use This Adjusted Exposure Time	—	None	None	None	None	None	15	—
	Change Developing Time by	—	None	None	None	None	None	None	—
T-MAX 400 Professional	Increase Lens Opening by	—	None	None	None	None	1/3 stop	1/2 stop	1 1/2 stops
	Or Use This Adjusted Exposure Time	—	No Change	No Change	No Change	No Change	Change Aperture	15	250
	Change Developing Time by	—	None	None	None	None	None	None	None
TRI-X Pan PLUS-X Pan*	Increase Lens Opening by	1 stop	1/2 stop	None	None	None	1 stop	2 stops	3 stops
	Or Use This Adjusted Exposure Time	Change Aperture	Change Aperture	No Change	No Change	No Change	2	50	1200
	Change Developing Time by	+20 percent	+15 percent	+10 percent	None	None	−10 percent	−20 percent	−30 percent
T-MAX 100 Professional	Increase Lens Opening by	—	1/3 stop	None	None	None	1/3 stop	1/2 stop	1 stop
	Or Use This Adjusted Exposure Time	—	Change Aperture	No Change	No Change	No Change	Change Aperture	15	200
	Change Developing Time by	—	None	None	None	None	None	None	None
Technical Pan	Increase Lens Opening by	—	None	None	None	None	None	1/2 stop	1 1/2 stops
	Or Use This Adjusted Exposure Time	—	No Change	No Change	No Change	No Change	No Change	15	NR
	Change Developing Time by	—	+30 percent	+20 percent	None	None	−10 percent	−10 percent	None

NR = Not Recommended.

*Information also applies to KODAK PLUS-X Pan Professional Film.

KODAK BLACK-AND-WHITE FILM TABLE

KODAK BLACK-AND-WHITE FILMS FOR EXISTING-LIGHT PHOTOGRAPHY

KODAK Film	Description	ISO Film Speed	Definition: Graininess	Resolving Power Lines per mm	Sharpness	Degree of Enlargement*	Number of Exposures Available
T-MAX P3200 Professional	An extremely high-speed, panchromatic film for use in existing light, such as sports stadiums and night events. This film is specially designed to be used as a multi-speed film. The nominal speed is EI 1000 when it is processed in KODAK T-MAX Developer or KODAK T-MAX RS Developer and Replenisher, or EI 800 when processed in other Kodak black-and-white developers.	EI 800–25,000†	Fine	High 125	High	Moderate	135-36
T-MAX 400 Professional	Features KODAK T-GRAIN Emulsions for the optimum combination of high speed, extremely fine grain, and very high sharpness. A 400-speed panchromatic film especially useful for photographing existing-light subjects, fast action, and subjects requiring good depth of field or high shutter speeds.	EI 400	Extremely Fine	High 125	Very High	High	135-24 135-36
TRI-X Pan	A favorite high-speed panchromatic film especially useful for photographing existing-light subjects, fast action, subjects requiring good depth of field or high shutter speeds.	ISO 400	Fine	High 100	High	Moderate	135-24 135-36
T-MAX 100 Professional	Superb definition quality together with medium speed provided by KODAK T-GRAIN Emulsions. An excellent, general-purpose panchromatic film that you can use for bright existing-light subjects when you want big enlargements.	EI 100	Extremely Fine	Very High 200	Extremely High	Very High	135-24 135-36
PLUS-X Pan	An excellent, general-purpose panchromatic film that offers medium speed, extremely fine grain, and a wide tonal range. Good for bright existing-light subjects when you need high definition quality.	ISO 125	Extremely Fine	High 125	Very High	High	135-24 135-36
High Speed Infrared	An infrared-sensitive film which produces striking and unusual results. With a red filter, blue sky photographs almost black and clouds look white. With this film and filter, live grass and trees will appear as though they are covered by snow. This film has fine grain.	125 Tungsten‡	Fine	Medium 80	Medium	Moderately Low	135-36
Technical Pan	A micro-fine grain panchromatic film with extremely high sharpness for giant-size enlargements. The film has extended red sensitivity. Good for stationary existing-light subjects when you need maximum definition quality, and high film speed is not important.	EI 25§	Micro Fine	Extremely High 320	Extremely High	Extremely High	135-36

*For good-quality negatives.

†To expose this film at speeds higher than EI 6400 (up to EI 25,000), it is critical that you make tests to determine if the results are appropriate for your needs.

‡Use this speed as a basis for determining your exposures with tungsten light when you expose the film through a No. 25 filter. In daylight, follow the exposure suggestions on the film instruction sheet.

§Use this speed for daylight pictorial photography only when processed in KODAK TECHNIDOL Developer, or the equivalent. Other speeds for different applications require alternative developers and give appropriate results. See the instructions packaged with the film.

Note: Panchromatic means that the film is sensitive to all visible colors.

61

Existing-Light Pictures at Home

The home environment and existing-light photography are a natural combination. The ordinary and sometimes extraordinary events of daily life provide a wealth of subjects, and the direct, uncomplicated techniques of existing-light photography permit recording them easily and naturally. Cameras with high-speed lenses and high-speed films allow impromptu, hand-held photography of everyday life without disrupting the activity.

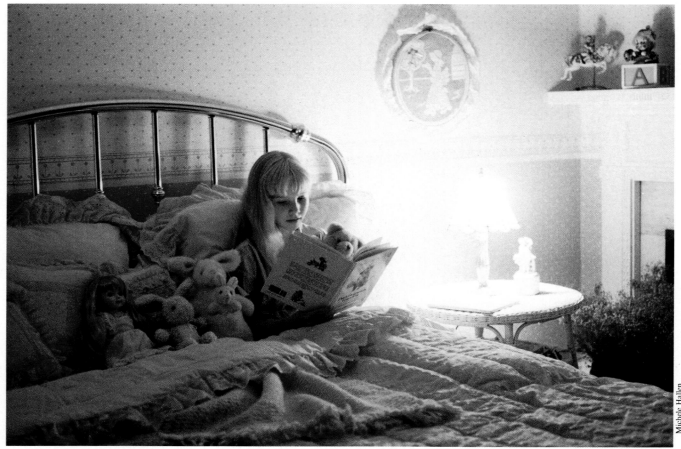

Michele Hallen

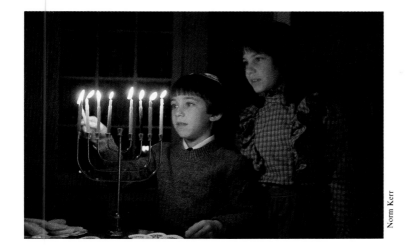

The major and minor events at home are natural subjects for existing-light photography. You can capture them easily with high-speed films. 1000-speed film, 1/30 second at f/4.

Norm Kerr

The following pointers will help you anticipate commonly encountered situations when taking existing-light photographs at home.

INDOOR LIGHT LEVELS

If you're not accustomed to photographing indoors without flash, you may be surprised to note how dim home lighting is compared with bright outdoor daylight conditions. Your exposure meter responds properly to the low light levels of indoor existing light, but it often appears to your eye that there's more light on the scene than there actually is. That's because the human eye has a remarkable capacity to adapt to a very wide range of lighting conditions, from bright sun to dim candlelight. In fact, in an average living room with a light-colored ceiling, with all the lights turned on at night, the light level is approximately 1/800 that of outdoor sunlight.

Effective photography indoors with a hand-held camera usually requires a high-speed film and a high-speed lens to keep shutter speeds fast enough to negate camera and/or subject movement. And don't overlook the possibility of push-processing color-slide or black-and-white film so that you can expose it at a higher film-speed number as described in the chapter on KODAK Films. This is beneficial when you're confronted with really dim environments and have difficulty getting enough exposure at the shutter speeds required for hand-holding your camera.

DAYLIGHT INDOORS

From dawn to dusk, many areas of the home may be lighted primarily by daylight and only partially, if at all, by artificial light. When daylight is dominant, use daylight-type color slide or color negative films and consider turning off or avoiding the effects of artificial light sources. Whether to turn the room lights on or off for existing-light pictures in the daytime is a matter of personal choice. Turning on the room lights may help fill in harsh shadows and reduce scene contrast, and will result in a higher light level. This works well with black-and-white film because you don't have to be concerned with color balance. But with daylight color film, since household lamps are usually tungsten, the parts of your subject illuminated by these light sources will appear warm or yellow-orange while the daylight portions will appear cooler and more neutral in color rendition. Some people do not object to this lighting mismatch and find it acceptable. See the photos on page 52. If truer color rendition is important, turn off the artificial light sources and consider reducing scene contrast by using one of the following methods.

Direct Sunlight

When the sun shines directly into a room, the potential exists for high scene contrast that may exceed the latitude of the film. In small rooms with white or light walls and ceilings, this is less likely to be a problem than in large rooms with less-reflective surfaces. The side of the subject facing the window will be brightly illuminated while other parts will be in deep shadow. You can reduce the contrast several ways.

Tom Beelmann

Direct sunlight flooding a small room with white or light walls and ceiling doesn't produce too much contrast because the walls and ceiling act as reflectors, bouncing light into areas that would otherwise be in deep shadow. In a large room with dark walls and ceiling, direct sunlight provides harsh, contrasty illumination because the walls and ceiling are too dark to bounce light effectively into the shadows.

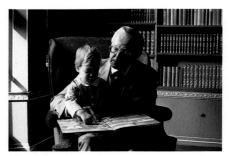

No reflector

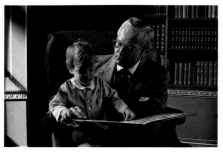

With reflector

Use an improvised reflector—in this case a projection screen—to bounce fill light into shadow areas you wish to lighten to reduce contrast. The closer the reflector, the brighter the fill light, but don't place it so close to the subject that it intrudes into the picture.

Improving the Existing Lighting

Although an existing-light purist might consider it cheating, you can reduce excessive scene contrast by adding light to the shaded areas of the subject to make them somewhat closer in brightness to the brightly lighted areas. Strictly speaking, this is not true existing light but the appearance in the photo is very similar. You can use reflectors to bounce light where it is needed, for example. You can

improvise reflectors from projection screens, large sheets of card stock, such as photographic mounting board, crumpled and then flattened aluminum foil, white sheets, pillow cases, or even newspaper pages that aren't too densely filled with print. The more efficient the reflector and the closer it is to the subject, the more the shadows will be filled with light. Do not use a colored reflector with color film unless you want a special effect. An exception to this advice is to use gold-colored aluminum foil to add warmth to a subject illuminated by window light from a blue or overcast sky.

Using Fill-In Flash

Here again, fill-in flash is not true existing light. But when handled skillfully, the pictures look like existing-light photos.

Some automatic cameras with built-in flash fire automatically as needed. Others have a fill-flash mode that gives different lighting ratios. See your camera manual.

When window light is too contrasty to produce a pleasing picture (left), you can reduce the contrast by using a flash unit to lighten the shadows (right). Lighting the shadows with fill so that they are 1 stop less bright than the highlights produced a natural-looking, pleasing picture on KODAK EKTACHROME 200 Film (Daylight). The fill light was from a flash unit, but a reflector could have done as well. See your camera and flash manuals for specific operating instructions.

With other types of cameras, you can use accessory flash units to fill in shadow areas with daylight-quality light either by aiming the flash directly at the subject or by bouncing the light of the flash from a nearby reflecting surface.

If your camera doesn't have any automatic fill-flash settings, here's how you can use fill flash. The technique of using fill-in flash is to adjust the intensity of the flash so that it's 1, 2, or 3 stops less than the intensity of the main lighting on the subject. See the discussion on fill-light intensities in the next section. First, make an exposure-meter reading of the subject area most brightly lighted by the ambient lighting as seen from the camera position. Say the exposure is 1/30 second at f/5.6 with 400-speed film and you want the shadow to be 2 stops darker than the highlighted areas. Always select the camera settings indicated by the meter reading to use a shutter speed recommended for the proper flash

synchronization for your camera and flash unit. Most cameras with focal-plane shutters will also synchronize at slower shutter speeds than the highest speed recommended for electronic flash. See your camera manual.

Next, set the controls on an automatic electronic flash unit for a lens opening 2 stops *larger* than the lens opening you'll use on your camera to take the picture. In the example, since $f/5.6$ is the camera setting, you would set the auto flash for $f/2.8$. This adjusts the flash to give 2 stops less light, which underexposes the shadows by 2 stops and gives the right amount of fill-in.

You can do this by adjusting the flash-unit controls for the lens opening and flash distance range or by changing the flash power setting to 1/2 or 1/4 power if your unit has this feature. The half-power setting gives 1 stop less light and the quarter-power setting 2 stops less light than full power. See your flash-unit manual for specific instructions about fill-flash operation. Note that this fill-in flash technique won't work with through-the-lens auto-flash exposure systems. With these systems, you should set the flash on manual for fill-in flash and follow the suggestions below for manual units.

If your flash unit does not have any of these controls, you can change the amount of fill-in by setting the flash on manual and moving it closer to or farther from the subject or by covering the flash reflector with layers of white handkerchief to achieve the proper amount of fill-light. One layer of handkerchief reduces the light by two stops and cuts the flash-to-subject distance in half. You can either use a zoom lens to help frame your subject in the viewfinder or use a flash extension cord, sold by photo dealers, to position the flash unit separately from the camera at the proper distance. Here again the objective is to adjust the intensity of the flash to give 2 stops less light. For the example given, adjust the flash for $f/2.8$. Since this provides proper exposure at a lens opening 2 stops larger than the one you're actually going to use on the camera, the flash fill-in intensity gives the desired 2-stops underexposure of the shadows. This will require some experimenting. See the flash exposure calculator on your flash unit.

Don't use colored surfaces to bounce fill light with color film unless you want to change the color of the filled-in area. Here, light reflected by a blue card discolors the shadow area (left). A white-card reflector produces a warmer, more natural rendition (right).

Keep It Looking Natural

For natural-looking fill-in illumination, don't overdo the technique. You can obtain pleasing results with color-negative films when the fill-lighted areas receive about 2 to 3 stops less light than the daylighted areas. This ratio also works well with most black-and-white films. With color-slide films, give the shadows about 1 to 2 stops less light than the daylighted areas. There is no hard-and-fast rule about precisely how much fill light to use, because the right amount is whatever makes the picture look the way you want it to look. Experience is the best guide.

When you use color film with bounced daylight, flash, or tungsten light, use white bounce surfaces or light neutral-colored surfaces. Bouncing light from colored surfaces will give an overall color cast to the picture. In black-and-white, the color of the bounce surface doesn't matter, except that light surfaces are more efficient reflectors than dark ones.

Soften the Daylight

If windows in the picture-taking area are furnished with white or neutral-colored translucent curtains, close them to take the edge off harsh sunlight. Sheer or translucent curtains will diffuse the light and soften overall contrast. This is an excellent technique for photographing people.

The contrasty picture (top) was made by direct sunlight flooding through the window. The softer version (bottom) was made with the translucent curtains closed. Closing the curtains lowered the light level by 1 stop, but improved the picture.

Move the Subject, the Camera, or Both

Sometimes the easiest way to cope with harsh window light is to change the subject's orientation to it, and/or the camera position relative to the subject and light source. For example, instead of photographing a person half-lighted by a window on your left side, move so that the window is completely behind you and turn the subject so that it's lighted more from the front. Be careful that your shadow doesn't fall on the subject or in the picture area.

Sometimes moving the subject deeper into the room, away from the window, will result in more even lighting. If the window isn't too large, try moving the subject to one side, where he or she is illuminated by diffused rather than direct light.

Indirect Daylight

One of the most pleasing forms of existing light is soft, indirect daylight. It may be produced by sunlight reflecting from a blue sky in classic north-skylight fashion, or it may be gentle diffused daylight from an overcast sky permeating the room. The lighting effects are much softer than those produced by direct sunlight and normally do not require any fill-in illumination. The lighting from an overcast sky is even better when there is nearby snow on the ground to reflect more soft light into the room on the first or second floor.

Indirect daylight is usually fairly cool in color quality. Color-slide films exposed by this light often exhibit a cool, or slightly bluish, color cast that may cause unpleasant skin-tone rendition in pictures of people. If you are photographing people on slide film, you may prefer to warm up the rendition with a No. 1A skylight filter over your camera lens. The filter is colorless and requires no additional exposure, but will remove the excess blue you may have with indirect daylight. The filter is not necessary with color-negative or black-and-white films.

You can't move a window, but you can change camera and subject positions for more pleasing lighting effects. Here the photographer moved so that the window would light the front of the subject from behind the camera position (left) rather than from the side (right).

Indirect daylight provided by sunlight reflected from the sky or from cloud cover is much softer than direct sunlight. Fill-in illumination is usually not necessary as long as the subject is not backlighted.

Determining Exposure for Indoor Daylight

Normal exposure-meter techniques work well when the overall contrast is low to moderate. If the lighting is harsh and/or uneven, make close-up readings of significant subject tones. If you are using fill-in illumination, make bright- and dark-area readings as you adjust the fill light until you achieve a good balance between light and dark tones. Be careful to exclude the window and other light sources from the exposure meter's field of view, or they will inflate the reading. If you are photographing toward the light, with the subject between the camera and the window, it is particularly important to avoid reading the bright window. If you do, you will greatly underexpose the subject. On the other hand, if you want a silhouette, read the window area, excluding the subject from the meter field, and expose as the meter indicates.

ARTIFICIAL LIGHT INDOORS

Artificial light indoors tends to fall into two broad categories: tungsten light, associated with home lighting, and fluorescent illumination, common to business and commercial establishments but also used for some home lighting. If you are

66

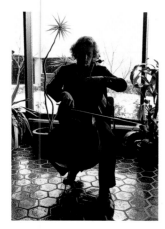

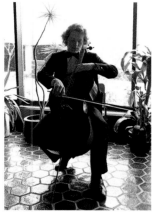

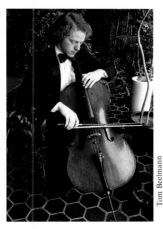

Tom Beelmann

When a window is behind the subject, don't let the exposure meter read the window unless you want to create a silhouette (top). Instead make a close-up meter reading of the subject to obtain proper exposure of the subject. However, this causes the window area to be overexposed (center). Also, shooting toward the window can cause the subject area to exhibit some possible camera flare. It's usually better to change your camera and/or subject position so the subject is lighted from the front or side by the window light (bottom).

using a color-slide film, use tungsten-balanced film for photographing by tungsten light and daylight-balanced film, with or without corrective filters, for photographing in fluorescent light. You can use Kodak color-negative and black-and-white films freely with tungsten and fluorescent lights.

Lighting effects produced by tungsten lamps are often quite different from those obtained with fluorescent tubes because of the different ways the two light sources are usually installed. Tungsten lighting is typically marked by pools of light near lamps, with darker areas separating them. The overall effect is often contrasty.

For taking pictures in tungsten existing lighting at home, household lamps with translucent shades are best. These shades diffuse the light, and increase the light level by transmitting a large proportion of the light from the lamp. Diffusing the light softens the shadow areas in the room and reduces contrast.

Generally it's best to turn on all the lights in the room for taking existing-light pictures. This helps make the lighting brighter and less contrasty. You can also increase the home lighting level by substituting higher-wattage tungsten bulbs or by turning the switch for three-way lamps to the brightest setting. This increases the light level without affecting the modeling or realism of the existing lighting. Do not use photographic lamps in household lighting fixtures or exceed the wattage rating specified for the light fixture.

Fluorescent lights are frequently installed in multi-tube banks or ceiling fixtures that spread light quite evenly over large areas. However, keep in mind that the overhead light sources can create unattractive shadows on people's faces and cause near-black eye sockets or other mournful-looking effects in pictures.

You can lighten the facial shadows cast by overhead fluorescent fixtures with fill from reflectors. Direct flash fill is difficult to balance to fluorescent color quality. However, you can improve the color quality of pictures taken under fluorescent illumination by bouncing light from an electronic flash off a white ceiling or by using camera filters. For pleasing informal portraits with color-slide films, the best solution is to photograph with daylight or tungsten sources.

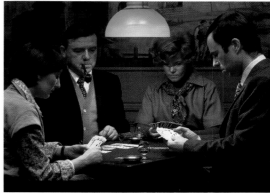

Kodak Pathé

Indoor tungsten lighting tends to be uneven and contrasty. Typically, there are bright islands of light with large dark areas separating them.

Tom Beelmann

Multiple-tube fluorescent lighting is often quite even. Usually, overhead installations cast shadows beneath objects, where they are less obvious, and the shadows are not intense or sharply defined. But overhead lighting sometimes creates deep, exaggerated shadows in people's eye sockets, which look unattractive in close-up photographs (top). Fill the shadows with a reflector, or have the subject tilt his or her head slightly upward toward the light (bottom). Better yet, move to a more favorable location.

A lighted lamp in the background put the girl's face in shadow (top). Moving the camera captured more pleasing lighting on the subject. EKTACHROME 160 Film (Tungsten) pushed 1 stop.

Watching the Shadows

With existing light, it is especially important to pay attention to the shadows. Every light source creates not only a highlight area but also a complementary shadow area. Indoor lighting, which is normally provided by multiple light sources in an area, can produce conflicting highlights and shadows in the scene. In real life, these effects aren't bothersome and generally pass unnoticed. In pictures, however, they can be very disturbing and create visual confusion.

View indoor subjects and settings critically, and pay special attention to shadow placement as well as intensity. Frame scenes so that extraneous or confusing shadows will be outside the picture area. A table or chair casting three or four separate, distinct sets of shadows in different directions can be an unsettling and unpleasant distraction in an otherwise attractive picture. When you cannot frame the picture to avoid multiple shadows, move the subject or turn off or relocate lights to solve the problem.

When you're taking pictures of a person or a pet, observe the shadows on your subject. Generally you should avoid photographing the subject with the face all in shadow, as it would be with a household lamp illuminating the subject from behind. You can avoid this by moving your subject to obtain more favorable lighting on the front or side of the face or by moving the lamp that's behind the subject. Also, remember that turning on other lights in the room helps lighten the shadows and increases the light level.

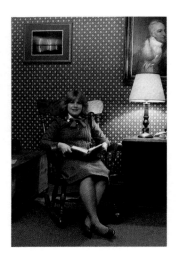

Bounce lighting from a photolamp made the room illumination more even and increased the light level for hand-held picture-taking. EKTACHROME 160 Film (Tungsten), 1/30 second, halfway between f/2.8 and f/4.

Adding Fill Light

You can also use fill lighting in many tungsten-lighted situations. Reflectors or suitable walls and ceilings can bounce supplementary tungsten light. You can use extra household lamps bounced or aimed directly or photolamps bounced to supplement existing tungsten lighting. This means you won't be taking true existing-light pictures, but this additional light can often improve the existing lighting without spoiling its natural appearance.

Adding fill light can reduce the lighting contrast and increase the light level. Bounce light from a 500-watt photolamp aimed at a white ceiling in addition to the room lighting can increase the amount of light by about 6 times. This extra illumination may let you use a shutter speed fast enough to hand-hold your camera or use a smaller lens opening for increased depth of field depending on the speed of the film you're using and the speed of your camera lens. Since bounce lighting makes the illumination more uniform, you can often use the same exposure for different areas of the room in the vicinity of the bounce lamp. This is especially convenient for taking pictures during a party or for photographing active subjects.

A 500-watt reflector photolamp in a clamp-on light socket makes a versatile bounce light. Both are sold by photo dealers. You can use a 3200 K or 3400 K photolamp; however, the former is closer in color to tungsten household lamps. Place the lamp about 3 to 5 feet from the ceiling and aim the lamp toward the ceiling area between your camera and your subject. Adjust the photolamp so that it doesn't illuminate the subject directly and overpower the existing lighting. *Be very careful when you use photolamps; they become very hot and will shatter if broken.*

Use the bounce-light exposure table for planning your pictures or as an exposure guide if your exposure meter isn't working.

SUGGESTED EXPOSURES FOR BOUNCE LIGHTING WITH A 500-WATT REFLECTOR-TYPE PHOTOLAMP PLUS ROOM LIGHTS

Film Speed	Shutter Speed	Lens Opening
For Color Prints		
1600	1/60 sec	f/8
800-1000	1/60 sec	f/5.6
400	1/60 sec	f/4
200	1/30 sec	f/4
100-125	1/30 sec	f/2.8
25	1/15 sec	f/2
For Black-and-White Prints		
800-1000	1/60 sec	f/5.6
400	1/60 sec	f/4
100-125	1/30 sec	f/2.8

Film Speed	Exposure Index	Shutter Speed	Lens Opening
For Color Slides			
1600	1600†	1/125 sec	f/5.6
	400† with No. 80A filter	1/60 sec	f/4
400	400*	1/60 sec	f/4
	100 with No. 80A filter	1/30 sec	f/2.8
320T	320	1/30 sec	f/4 ↓ 5.6
200	200*	1/30 sec	f/4
160T	160	1/30 sec	f/2.8 ↓ 4
100	100*	1/30 sec	f/2.8
64	64*	1/30 sec	f/2 ↓ 2.8
64T	64	1/30 sec	f/2 ↓ 2.8

Note: The ↓ symbol indicates an aperture opening halfway between two f-stops.
*Pictures taken with daylight film and no filter will look yellow-red.
†With push 2 processing.

Determining Exposure for Artificial Light Indoors

Making close-up exposure-meter readings of significant subject tones or incident-light meter readings at the subject position are the most reliable ways of determining exposure indoors under artificial light. In tungsten-lighted areas, be sure to exclude lamps and light fixtures from a reflected-light meter's field or you will get a reading too high for correct exposure of average-toned subject matter. In fluorescent-lighted areas, don't make exposure-meter readings with your camera or hand-held meter tilted upward to include ceiling fixtures in the reading area. And remember to use shutter speeds slower than 1/60 second under fluorescent illumination to avoid uneven exposure or underexposure, even when the light level tempts you to choose a faster shutter speed. In general, rely on meter readings or an exposure table to determine camera settings. Judging indoor lighting can be deceiving even for experienced photographers, because the eye is not reliable for evaluating light levels.

PHOTOGRAPHING TELEVISION AND COMPUTER SCREEN IMAGES

Another interesting form of existing-light photography at home is recording images from your television screen. The fleeting electronic pictures glowing on the screen may represent important history in the making, dramatic sports action, lighthearted entertainment, or simply scenes of beauty worth preserving in photographs. Or perhaps you want conventional still pictures of personal events you've captured with a home video recorder. Whatever the reason, it's easy to do. You'll need reasonably fast daylight-balanced color film or black-and-white film, a tripod, a cable release, and a camera that can focus close enough to fill the frame with the TV image.

You can also use the techniques given in this section to photograph important information or interesting designs you've created on your home-computer display screen. These computers may use your home television set as a display screen or a computer monitor that is quite similar to a conventional TV.

James H. V. Bright

Photographing images on a television screen lets you preserve fleeting moments that may range from historic events to personal pleasures. Photographed from English television.

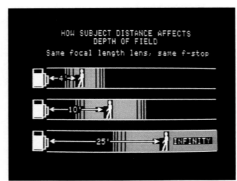

Caroline Grimes

You can use the same techniques for photographing TV images and your home computer display screen. EKTACHROME 200 Film (Daylight), 1/8 second between f/4 and f/5.6; exposure was increased for the dark background.

Adjusting TV Picture and Computer Screen Image Quality

Begin by adjusting your TV set or computer screen to produce a picture or image of slightly lower-than-normal contrast. Adjust the brightness control so that the image shows some detail in both highlight (light) and shadow (dark) areas. If necessary, adjust the color controls to produce pleasing color quality. If your TV set or computer monitor has an automatic brightness control that adjusts picture brightness to changing levels of room lighting, switch the automatic system off and control the brightness manually. This will prevent picture brightness from changing when you turn off the room lights.

If you can't turn the sensor off, put a piece of black tape over the sensor to prevent it from working. This dims the screen and permits you to adjust the brightness manually.

Positioning the Camera

Mount your camera on the tripod, level it side to side and front to back, and then adjust the height until the center of the camera lens is at exactly the same distance from the floor as the center of the TV or computer screen. Position the tripod and camera so that the lens axis is exactly perpendicular to the face of the screen. Fill the viewfinder of the camera with the screen image as closely as possible. With some cameras, you may have to use supplementary close-up attachments to fill the frame with the TV or computer screen image. If you are not using an SLR camera, your camera manual will tell you how to correct for parallax, the difference at close ranges between what you see through the finder and what the film "sees" through the camera lens.

When you frame the image, raise or lower the tripod column to make changes in vertical placement of the image, and slide the whole tripod sideways to change the horizontal position. This helps keep the film in the camera and the TV screen parallel.

Focusing for Overall Sharpness

With an SLR camera, focus on the TV or computer screen at a point about halfway between the center of the screen and a corner. That helps achieve a good overall focus that allows for the curvature of the image screen of the picture tube. With a rangefinder camera, focus on picture detail in the center of the screen; then "cheat" the focus a little to a *slightly* more distant setting on the focusing scale to achieve the same type of compromise setting.

To eliminate reflections on the face of the TV or computer screen, turn off all room lights. During the day, draw the blinds to prevent daylight from washing out the image on the screen or causing reflections on the tube. Do not use flash or photolamps to illuminate the image screen because these light sources would overpower the image and you would get a picture of a blank screen.

Determining Exposure

Determine exposure by referring to the table or by making a close-up reading of the TV or computer screen image with a reflected-light exposure meter. If you haven't photographed TV images before, compare the exposure settings indicated by the meter reading with the data in the table. Some light meters do not read TV or computer screen images accurately. If there is a big discrepancy, set the exposure according to the table. For more

After you have properly aligned your camera with the TV or computer screen, focus on a part of the screen indicated by one of the Xs in the illustration. This gives a good compromise focus setting that allows for the curvature of the screen. Stopping the lens down provides the necessary depth of field to cover the center and edges of the screen.

assurance of proper exposure, bracket the estimated exposure by plus or minus 1 or 2 stops in 1/2-stop increments. Note that for best color rendition with color films, you should use a color compensating filter, and increase the exposure indicated in the table.

You can use the same exposures given in the table to photograph your home computer screen. If you want to photograph computer-monitor display images in full color, use the exposures in the table for color television and computer screens. If the screen is monochrome and displays images in black-and-white or tinted in one color, such as green, use the exposures for black-and-white television and computer screens.

It's a good idea to bracket the exposure until you're familiar with your equipment. A computer display image with a white or very light background may require 1/2 to 1 stop less exposure than suggested in the table. A display image with a black or very dark background may require 1/2 to 1 1/2 stops more exposure than given in the table.

SUGGESTED CAMERA SETTINGS FOR PICTURES OF TELEVISION AND COMPUTER DISPLAY SCREEN IMAGES

Film Speed	Color Television set or Computer Screen		Black-and-White Television Set or Computer screen	
	Focal-Plane Shutter	Leaf Shutter	Focal-Plane Shutter	Leaf Shutter
64-speed Color Film	1/8 sec f/4	1/15 sec f/2.8 or 1/30 sec f/2	1/8 sec f/2.8	1/8 sec f/2.8 or 1/15 sec f/2
100-speed Color Film	1/8 sec f/5.6	1/30 sec f/2.8	1/8 sec f/4	1/30 sec f/2
200-speed Color Film	1/8 sec f/8	1/30 sec f/4	1/8 sec f/5.6	1/30 sec f/2.8
400-speed Color Film	1/8 sec f/11	1/30 sec f/5.6	1/8 sec f/8	1/30 sec f/4
1000-speed Color Film	1/8 sec f/16	1/30 sec f/8	1/8 sec f/11	1/30 sec f/5.6
100-speed Black-and-White Film	1/8 sec f/8	1/30 sec f/4	1/8 sec f/8	1/30 sec f/4
400-speed Black-and-White Film	1/8 sec f/16	1/30 sec f/8	1/8 sec f/16	1/30 sec f/8
T-Max P3200 Professional EI 800	1/8 sec f/22	1/30 sec f/11	1/8 sec f/22	1/30 sec f/11

Important: With focal-plane shutters, use a shutter speed of 1/8 second or slower. With leaf shutters, use a shutter speed of 1/30 second or slower. These precautions are necessary to prevent dark streaks in your pictures. Use a tripod or other camera support for shutter speeds slower than 1/30 second.

Bruce Nett

To capture the entire television or computer screen image uniformly, use shutter speeds no faster than 1/8 second with a focal-plane shutter or 1/30 second with a leaf shutter. The pictures above were made on EKTACHROME 400 Film (Daylight) with a focal-plane-shutter 35 mm SLR. The one on the top was exposed for 1/8 second at f/11. The one on the bottom, exposed for 1/125 second at f/2.8, failed to record the image uniformly.

Suitable Shutter Speeds

TV and computer screen images are formed on the image tube (also referred to as a cathode ray tube—CRT) line by line by a rapidly moving electron beam that scans the television picture or computer image. Therefore, you have to select a relatively slow shutter speed to give the beam time to form a complete, uniform image during the exposure. In the U.S., to obtain a uniform image, use a shutter speed no faster than 1/30 second with a leaf-shutter camera and no faster than 1/8 second with a camera that has a focal-plane shutter. In other countries that have a standardized 625-line TV picture rather than the U.S. 525-line picture, use a shutter speed no faster than 1/25 second for a leaf shutter or a shutter speed no faster than 1/8 second for a focal-plane shutter. Since 1/30 second is so close to 1/25 second, try the 1/30 setting with your leaf-shutter camera to see if you get a complete TV image. If not, you'll have to use 1/15 second or slower.

If you use a camera with a focal-plane shutter but want to record moderate on-screen action more sharply than a 1/8-second exposure permits, you can try 1/15 or 1/30 second with a correspondingly larger lens aperture. Some slight streaking will be evident in the pictures.

Variations in TV sets also make it a good idea to bracket exposures until you gain experience with your particular set. You may also want to experiment with color filtration or the color adjustments of your TV set to obtain optimum color quality with color-slide films. Because of the slow shutter speeds required to record a uniform image, time your exposures to coincide with peaks or lulls in on-screen action.

Copyright Considerations

Many television programs, video tapes, videodiscs, video games, and computer screen images are copyrighted. Taking pictures of images or making video or sound recordings of copyrighted materials may be subject to copyright regulations. Responsibility for complying with copyright laws must remain with the person taking the photograph or making the recording of a specific television program, image, or sound. Eastman Kodak Company can take no responsibility for copyright matters.

Existing-Light Photography in Public Places

A world of picture opportunities is waiting outside the home, and many of these picture-taking opportunities are available only to existing-light photographers. Indoors and outdoors, down the street or halfway around the world, subjects of interest abound. Some, like creatures of the night, disappear by day. And others, Cinderella-like, may be drab by day but radiant after dark. On the following pages are suggestions for photographing a variety of existing-light subjects and practical tips on how to do it.

Dusk, when there is still color in the sky, is a good time to photograph skylines and other illuminated night subjects. Make a reflected-light reading of the sky; then give about 1/2 or 1 stop less exposure than the meter indicates to keep the sky dark in the picture.

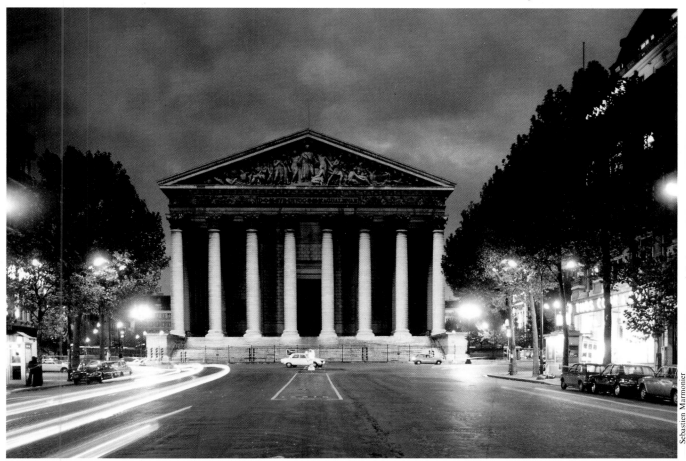

Sebastien Marmonier

73

For outdoor night photography, it's convenient to use a very high-speed film to be prepared for various subject opportunities. Here the photographer chose a handheld camera set at a small lens opening for adequate depth of field. Sodium-vapor airport lighting.

Bruce Nett

OUTDOOR SCENES AT NIGHT

For the most part, outdoor scenes at night consist of highlight areas and dark areas, with few or no middletones separating them. The highlights are nearly always the true subjects. Base your exposures primarily on highlight and middletone readings and don't allow large masses of dark surroundings to "trick" your exposure meter into recommending overexposure. Use high-speed film for hand-held picture-taking or be prepared to use a tripod or an improvised camera support for longer exposures with slower films. And take along a small flashlight for reading exposure-meter scales and camera settings, as well as a small notebook to keep track of exposures used and other data. Early evening, when the lights are on and there is still some color in the sky, is a good time to shoot city skylines and large subjects, such as buildings and monuments, with a deep-blue sky or orange sunset background.

Street Scenes

Shopping thoroughfares and entertainment districts are rich in after-dark existing-light subjects. Since outdoor light sources are a variety; you can make attractive overall shots on either daylight- or tungsten-balanced color-slide films, depending on whether you prefer a warmer or cooler rendition. It's a good idea to carry both types of film, though, because pictures that isolate specific areas, such as pictures taken at close subject distances, may look much better on one type of film than on another. This is particularly true when people are prominent and you want to avoid excessively warm or cold skin tones. For photographing window displays, tungsten color-slide films are usually compatible with display illumination. When in doubt or when you want color prints, use one of the KODAK GOLD Films or KODAK EKTAR Films, which produce generally excellent results in night photography. For black-and-white prints, T-MAX 400 Professional Film is a superb film for outdoor night scenes.

If you have two camera bodies or two cameras, load one with daylight-balanced color-slide film, for example, and the other with a tungsten-balanced slide film or perhaps a high-speed color-negative or black-and-white film. That way you're ready for almost any lighting condition. Identify the film type in each camera body. Many 35 mm SLRs are equipped with frames on the camera back that will accept the end flap from a film carton as a reminder of the film in use. If your camera doesn't have a film-reminder device, stick a good-sized strip of masking tape on the back cover or camera base, and write the film type on it with a bold marker so that you can read it easily in dim light.

If you don't have two 35 mm camera bodies, you can change to a different film in the middle of the roll. Before opening the camera back, first note and record the number of exposures on the camera frame counter. Then carefully rewind the film, but not completely, so that the leader sticks out of the film magazine for reloading. By rewinding slowly and carefully, you can tell when the film leader pulls loose from the take-up spool. Then you can load a different kind of film in the camera.

Caroline Grimes

You can use tungsten- or daylight-balanced color-slide films to photograph street scenes at night. Tungsten films produce a cooler rendition; daylight films produce warmer colors. This scene was photographed on EKTACHROME 160 Film (Tungsten)—top—and EKTACHROME 400 Film (Daylight)—bottom. Exposures were 1/30 second at f/4 and 1/60 second at f/4, respectively.

Caroline Grimes

Tungsten-balanced color-slide films usually produce attractive color rendition under the tungsten light used to illuminate many display windows. Here the photographer used EKTACHROME 160 Film (Tungsten), 1/30 second at f/2.8.

Later, when you reload the partially exposed film magazine, load it exactly like you did the first time. Then, with the camera back closed and a lens cap or your hand tightly covering the lens, advance the film to the same frame number on the camera frame counter that you recorded when you took the film out of the camera and add two more. The two extra frames should prevent double exposures after reloading.

Plan nocturnal picture prowls to coincide with an area's peak of activity. If you show up too early, too late, or on an off night, the scene may be deserted and too dark. But sometimes this can make an interesting picture, too, and provide an unexpected contrast to the conventional view.

Don't let less-than-perfect weather stop you from seeking street pictures at night. Rain-slick surfaces and pools of water reflect lights attractively. Sometimes the reflections are even more interesting than the subjects they mirror.

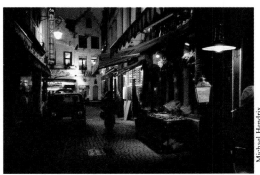

Michael Hendrix

The busiest shopping and entertainment areas will be deserted if you arrive too early, too late, or on an off evening. On the other hand, a picture showing a normally bustling street in a quiet mood can be effective, too.

Don't let rain stop you from photographing street scenes at night. Wet streets after a rainstorm add interest to night scenes by reflecting lights and illuminating signs. This photograph was made on KODAK EKTACHROME 160 Film (Tungsten).

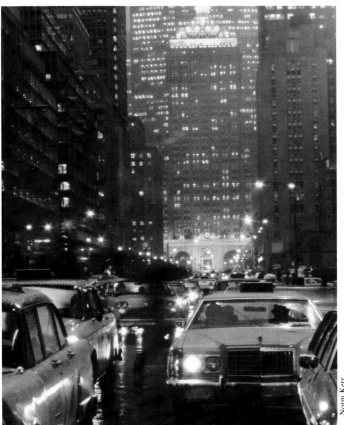

Norm Kerr

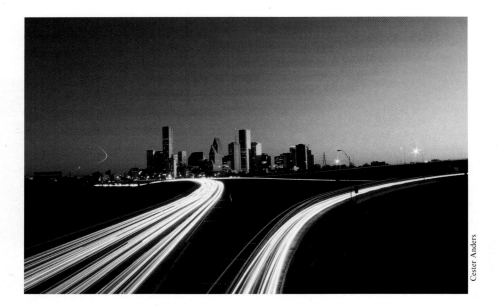

Cester Anders

A tripod-mounted camera and long exposures of several seconds let you record patterns and trails formed by the lights of moving traffic after dark. You can use KODAK GOLD Films for color prints. If you prefer a warm color-slide rendition, choose a daylight-balanced color-slide film; for a cooler color rendition, choose a tungsten-balanced film.

Traffic Patterns

Headlights and taillights of moving autos can trace interesting patterns on film during long exposures. The effects you can record are limited only by the roads, the traffic, arteries available, your viewpoint, and your imagination. A single car moving along an otherwise deserted avenue, a look down at a busy intersection or freeway cloverleaf, views of expressway traffic from an overpass—wherever there are cars and roadways you'll find subject matter for nighttime pictures.

For long, flowing streaks of light, use exposures long enough to allow the images of the light sources to move far enough on the film to produce the effect you want. An exposure of about 30 seconds usually works well with car traffic. Be alert to traffic light cycles so that you don't record stationary vehicles stopped for a red light. Using exposure times that require a camera support means you can use, for example, ISO 64 films. You can use faster films, too, by selecting smaller lens apertures that allow longer exposure times. For warm results in color slides, select daylight-balanced slide film. For cooler rendition, choose a tungsten film. If you want color prints and you'd like to decide on the specific color rendition later by doing your own printing in the darkroom, use KODAK GOLD or KODAK ROYAL GOLD Film.

If a street scene or lighted monument is prominent in the background, choose an exposure that will show it the way you prefer while allowing a long enough exposure to register light trails of the length you want. For example, if you would normally expose KODAK GOLD 400 Film at 1/15 second and $f/2$ to record the monument, you could achieve approximately the same exposure level at 4 seconds and $f/11$, allowing plus 1 stop to correct for the reciprocity effects of using a long exposure time and to capture longer trails of moving lights.

Exposure times required for good streak effects are too long for handheld photography. Use a tripod or improvised support to steady your camera. Bracket exposures generously until you develop a sixth sense about suitable shutter speeds and exposure times for the situations you like to photograph. Unless there is important subject matter of known color in the scene, don't worry about correcting moderate color shifts that result from reciprocity effects. Moderately long exposures of about 30 seconds will cause some reciprocity effects with many films, but they will be minimal and the results are usually acceptable for outdoor night subjects. These subjects are less critical for precise color rendition than indoor subjects. Optimum color rendition is impractical in photographs of many highways and streets because the illumination appears bluish-green or amber, depending on the light sources.

If the table on page 60 tells you that the exposure time will produce a loss of film speed of 1 stop or more, increase your exposure by the amount in the table.

Holiday Lighting

Religious and secular holidays are often marked by festive lighting displays that invite photography. Brightly colored lights and ornaments adorn trees, shop windows, main streets, houses, and front yards. Choose film and exposure as you would for any other subject consisting primarily of light sources. You can embellish your photographs by shooting through any of the numerous star-effect filters available through photo dealers. These filters produce spikes of light that radiate from bright lights. They are most effective with a discrete light source that appears against a dark background. Wide lens apertures produce thicker, softer-edged radial patterns and more diffusion. Stopping down slightly to moderate apertures thins the radial patterns and renders them and the image sharper. Don't stop down too far, though, or the star effect may be lost. If you use an SLR camera with a depth-of-field preview feature, judge the star pattern with the lens stopped down to shooting aperture, and then open or close the diaphragm as necessary to control the effect.

Holiday lights create interesting reflections in wet weather, and they cast subtle colors on clean snow. In cold weather, keep your camera under your coat when you're not actually using it. Batteries and internal mechanisms may become sluggish if exposed to very cold temperatures for long periods.

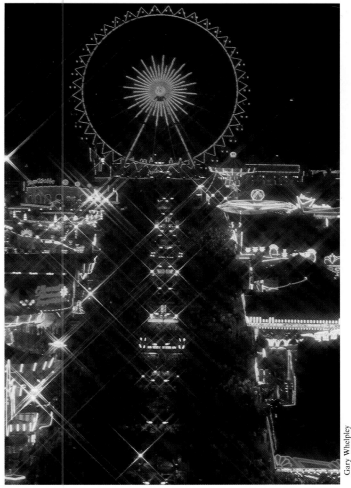

Gary Whelpley

Arthur Ketchum

To emphasize the water flow, photograph an illuminated fountain at a slow shutter speed, or make a long exposure with a tripod-mounted camera. To obtain the blurred-water effect, you can use an exposure time of 4 seconds.

Star-effect filters, available through photo dealers, can turn bright lights into dazzling star patterns. The effect is most pronounced when the light source appears against a dark or black background. This photograph, taken during Oktoberfest, was made on KODACHROME 64 Film (Daylight).

Floodlighted Structures

Buildings, monuments, statues, and fountains of special scenic, historic, or civic interest are often illuminated by floodlights. The dramatic lighting effects sometimes make the structure look better by night than by day. Normal exposure-meter techniques produce good results if you take care not to include light sources in the meter field when the structure itself is the subject of interest, and if you make close-up readings of the subject to avoid the dark surround of the night sky. A film with an ISO speed of 400 will usually allow exposures of 1/15 second or 1/30 second at $f/2$, so you may be able to make hand-held pictures with fast, normal, or wide-angle lenses. Fountains that feature eye-catching water jets or cascades may look more dramatic if you use a relatively slow shutter speed or time exposure with a tripod-mounted camera to blur the water flow enough to convey the feeling of motion.

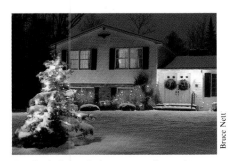

Bruce Nett

Bright holiday lights are perfect subjects for existing-light photographs. With fast film, you can use shutter speeds fast enough for hand-held photography, as was done here with 400-speed Kodak film (1/60 second at f/4).

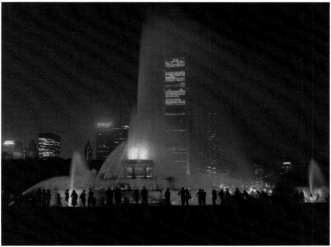

Kodak Pathé

Historic buildings and monuments are often floodlighted after dark. Normal exposure meter techniques work well, but reading the lights themselves causes underexposure, and reading the black night sky causes overexposure.

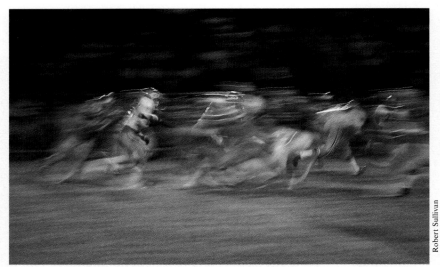

Robert Sullivan

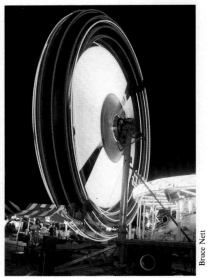

Bruce Nett

Outdoor Sports at Night

Well-lighted outdoor stadiums and playing fields offer excellent opportunities to make dramatic photographs of sports action ranging from neighborhood softball games to professional auto races. Light sources may be tungsten lights, daylight-quality Multi-Vapor lighting, or possibly mercury-vapor lamps.

In bright tungsten lighting, use 160-speed tungsten film for the most realistic rendition in color slides. Push process if necessary to gain the extra film speed you need to stop action. In Multi-Vapor lighting, use 400-speed film and 1600-speed film for well-balanced color slides, and push process the 400-speed film if required. With mercury-vapor lamps, use a high-speed daylight-balanced color slide film if you must have transparencies, although color rendition won't be ideal. 400- and 1000-speed color print films are excellent choices with all three light sources. For black-and-white prints, you can choose KODAK T-MAX 400 Professional Film, T-MAX P3200 Professional Film, or TRI-X Pan Film. If you need a higher-speed film to let you use higher shutter speeds to stop action in dim light, you can expose these films at a higher film-speed number and then push process them.

If you cannot use a shutter speed fast enough to freeze the action, or if you want some movement in the picture to heighten the impression of speed, use a slower shutter speed and pan the camera with the moving subject. This picture was made by panning with the subject at 1/30 second and f/4.

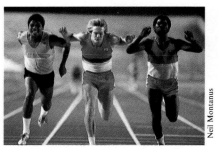

Neil Montanus

Outdoor playing fields, stadiums, and racetracks are usually lighted well enough to permit making action-stopping photographs with high-speed films. Here the photographer caught the action at 1/500 second and f/2.8 on 1000-speed color-negative print film.

Try to find a shooting position close to the action so that you won't need long focal-length telephoto lenses, which magnify camera movement along with the image. And if you can't use shutter speeds fast enough to stop subject motion, take pictures when the action is suspended for a moment. Also, you can pan with the action as described on page 24.

Lighted action rides at amusement parks and carnivals trace interesting patterns during long exposures. Mount the camera on a tripod. This picture was exposed for 4 seconds on KODACHROME 64 Film (Daylight).

Fairs and Amusement Parks

It's the colorful lighting that sets the mood at fairs and amusement parks outdoors at night and makes good pictures. You can easily take hand-held exposures of interesting arrays of lights with high-speed film. For pictures that go a bit beyond the ordinary, try photographing lighted action rides and Ferris wheels with a tripod-mounted camera at exposure times slow enough to record swirls and patterns formed by the moving lights. With color-slide films, select the balance to suit your taste: daylight films for warmer results, tungsten films for cooler colors. KODAK GOLD Films give excellent photos of these subjects. If you do your own darkroom work or have your prints made by a custom processing laboratory, KODAK GOLD Films will let you choose the balance you like. In crowded areas or on action rides, sling your camera so that it nestles between your arm and side for protection from bumps.

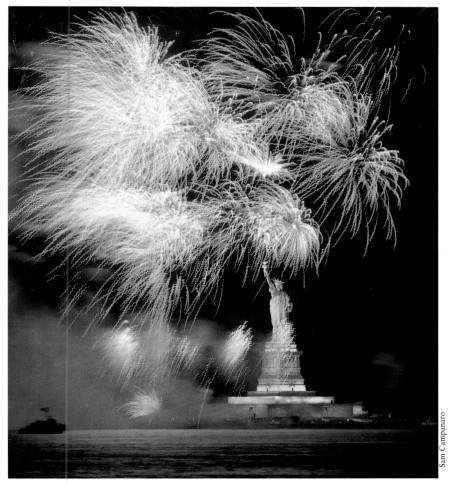

Sam Campanaro

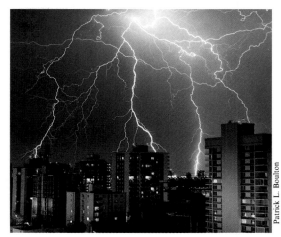

Patrick L. Boulton

Several lightning flashes look more dramatic on film than a single flash does. Mount your camera on a tripod with the shutter set at B, and aim it in the direction of the storm. Close the shutter after several strong flashes in the picture area. Photograph from indoors or a substantial shelter. Never remain in the open when lightning is in the area. For color prints, you could use KODAK GOLD 400 Film with the shutter open on B, and the aperture at f/11.

You can add interest to pictures of fireworks by collecting several bursts on each frame of film. You can do this with a tripod-mounted camera with the shutter open at the B setting. Or you can take several successive multiple exposures of individual bursts with a hand-held camera. You can take a picture like this one by setting the shutter on B and keeping it open until several bursts occur. Set the lens opening according to the chart on page 42 for your film speed.

Fireworks and Lightning

Taking pictures of fireworks displays or lightning is a form of flash photography in reverse. Instead of photographing what the flash illuminates, you're photographing the flash itself.

You can photograph aerial fireworks best with a tripod-mounted camera. Aim your camera at the area where most bursts are occurring, set the focus on infinity, and set the lens opening as suggested in the table on page 42. Set the shutter on B, open it when a burst occurs, and keep it open until you have collected several successive bursts on the same frame of film. If you don't have a tripod, camera settings of 1/30 second at f/2.8 for ISO 200 films, such as EKTACHROME 200 Film (Daylight), permit making hand-held shots of individual bursts. With slower or faster films, increase or reduce the exposure appropriately.

The most opportune time to take fireworks pictures with a hand-held camera is during the finale when several bursts are filling the sky. If you're using an autofocus camera, set the focus manually on infinity, if possible. See your camera manual. If you can't set the focus manually, take a test shot of the fireworks and then check the focus indicator to determine whether your camera is focusing properly on infinity. Infinity is indicated by a figure eight on its side ∞ or by a distant-scene symbol, such as mountains.

If your camera has a multiple-exposure control that lets you make more than one exposure on a single film frame, you can collect several bursts in one picture by making multiple exposures. With this technique, be sure to aim your camera at the sky so that it doesn't include any objects on the ground that would cause confusing multiple ground images. You can also leave the shutter open during several bursts; use a hat to cover the lens between bursts to prevent overexposure.

Fireworks displays over water create colorful reflections on the surface. Enhance your pictures by photographing both the displays and their reflections for more interesting effects. Include a skyline, foreground object, or possibly an illuminated monument in the frame to add dimension. Use a medium telephoto lens to fill the frame dramatically when you can use a tripod and you have a good idea where the bursts will occur. If you want to use a telephoto lens without a tripod, brace the camera for added steadiness, or camera movement may mar the intricate tracery of the bursts.

You can record fairly static ground displays of fireworks well with shutter speeds fast enough for hand-holding your camera. Select exposure settings from the table on page 42. Daylight color films render fireworks very attractively.

Photographing lightning bolts is like photographing fireworks; but there is a greater element of chance, as you don't know exactly where the lightning flash will be or when it will come. Mount your

camera on a tripod and use a normal or wide-angle lens to include a good expanse of sky area where bursts are likely to occur. Set the lens aperture as suggested in the table on page 42, and hold the shutter open at the B setting long enough to record several flashes. For safety's sake, take lightning photographs from indoors through a window or doorway or from some other substantial shelter. Don't under any circumstances station yourself outdoors in the open with a tripod when lightning conditions exist because you or the tripod could become a lightning rod. And don't take cover under a tree, either. Trees attract lightning strikes, too. A safer place to be is in a car with a metal top, but don't touch any metal parts of the car.

When you have to keep the shutter open for awhile until you collect several flashes, try to exclude lighted areas from the frame. If lights of passing vehicles enter on the scene, either plan your picture to use the light streaks as part of the design, or cover the lens with a black card or a hat to keep the streaks from recording. Uncover the lens again when the vehicles have left the scene.

EXISTING-LIGHT PICTURES INDOORS IN PUBLIC PLACES

The materials and methods you're accustomed to using for taking existing-light pictures indoors at home are applicable to picture-taking indoors in public places. One important difference, though, is that making pictures in public places requires a bit more planning. Try to anticipate shooting conditions so that you will arrive prepared. You won't be able to step into the next room for an extra roll of film or one of a different type, and you cannot simply retrieve your tripod from the hall closet when you're across town or half a country away from home. Another difference is that you will rarely have the option of altering the environment to improve the photographic conditions. You aren't free to change stage lighting, rearrange furnishings in a restaurant, or move a display in a museum or gallery to a spot with better lighting. However, you can make pleasing photographs of events, activities, objects, and settings you encounter in many public places. Consider the following possibilities.

Museums and Art Galleries

Art objects, artifacts, and dramatic dioramas are inviting subjects in art galleries and museums. In the more modern facilities, display lighting is often artfully arranged to bring out the best in the displays, making them easy to photograph well. If you have a macro lens or other close-focusing optic, be sure to take it with you to help isolate small objects and eliminate surrounding clutter. A wide-angle lens can be helpful for photographing large three-dimensional displays and dioramas. It lets you take in the area you want to cover without having to back up so far that other visitors keep getting between you and the subject. Sometimes there's not enough space to move back far enough to include what you want in the photo when you're using a normal-focal-length lens.

If you're shooting color slides, take both daylight- and tungsten-balanced films with you. It isn't uncommon to encounter galleries illuminated by skylight, others illuminated by fluorescent tubes, and still others lighted by tungsten sources in a single museum. In fact, you may find mixed lighting quite often. Don't be surprised if area lighting is provided by skylights or fluorescent fixtures while individual displays are bathed by small tungsten spot- and floodlights. Choose the film according to the lighting that affects the specific subject you're photographing. Two cameras loaded with films of different balance make it easier to win the lighting game. Or load a single camera with EKTACHROME 160 Film (Tungsten) and take along a No. 85B conversion filter for use with daylight or fluorescent lights. If you push the film 1 stop, you can rate it at ISO 320 with no filter and ISO 200 with the filter, which should be fast enough for many museum and gallery light levels. When you want color prints, KODAK GOLD 400 Film has ample speed for photographing displays that are adequately lighted for good viewing with a hand-held camera that has a fast lens. For brightly lighted areas, you can use this same film or KODAK GOLD 200 Film.

Don't count on using a tripod or flash unit to supplement existing light. Most museums and galleries prohibit the use of a tripod, and some prohibit flash. Check with the staff ahead of time to be sure. If

Museums and art galleries offer a wealth of subjects to existing-light photographers. As a rule, sculpture and other three-dimensional museum pieces are lighted better for photography than are paintings and drawings. EKTACHROME 160 Film (Tungsten) with Push-1 Processing, ISO 320.

A close-focusing or macro lens is handy for isolating small objects and displays from distracting surroundings. Use a very high-speed film.

Keep your eye on other visitors, too. Their reactions to exhibits can provide engaging human-interest pictures.

you're lucky, you may be able to obtain special permission. However, with the excellent high-speed films and high-speed lenses that are available today, you can usually take existing-light pictures with a handheld camera. Keep this advantage of existing-light photography in mind: It's least disturbing to the environment and captures the effectiveness of the creative display lighting. Some museums charge a nominal extra fee if you want to take pictures, and some do not allow photography at all. Again, check ahead of time to avoid disappointment.

In the majority of museums that do permit photography, look beyond the exhibits for subjects. Other visitors and their reactions to exhibits can provide engaging human interest.

Photographing paintings is very difficult to do well by using informal existing-light techniques. You will usually do better by buying an inexpensive copy or postcard of the painting at the museum gift shop and using your film to record objects and people.

Circuses and Ice Shows

Exuberant performers and blazing colors make ice shows and circuses photogenic subjects that are hard to top. Try to get seats with a good view of the part of the arena where acts in which you are most interested are scheduled to perform. If there is a printed program, browse through it ahead of time to help pace your shooting. You don't want to be changing film at the height of the action. If your seats are farther from ring- or rinkside than you'd like, use a fast telephoto or zoom lens of moderate focal length to tighten composition. And use the highest shutter speeds you can to stop whirling figure skaters or swooping aerialists.

Light levels are generally high enough to permit shutter speeds from 1/60 second to 1/250 second at $f/2.8$ with ISO 400 films. The lower end of the speed range is appropriate to tungsten-lighted areas, the higher end for main events spotlighted by carbon arcs. Daylight-type color-slide films produce realistic color rendition under carbon-arc spotlighting, while tungsten films yield more accurate color balance under tungsten illumination. If it isn't convenient or practical for you to use both types,

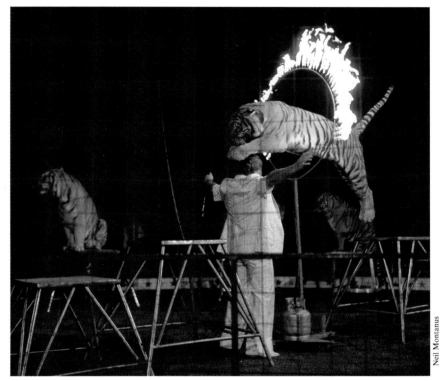

Neil Montanus

High-speed film let the photographer use a fast shutter speed to stop the action of the tiger.

Exposure was 1/250 second at $f/3.5$. A moderate telephoto lens helped bridge the distance from seat to action. Alberto Zoppé produced Circus Europa.

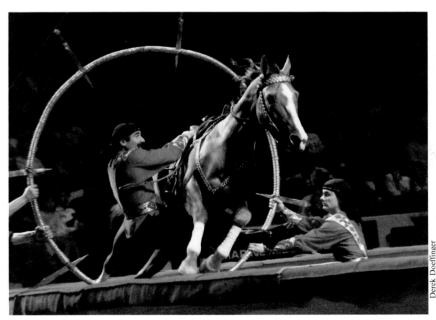

Derek Doeffinger

The Moscow Circus, produced by Steven E. Leber.

use a daylight-balanced film for everything. When special multicolored lighting effects are part of an act, you'll get arresting pictures regardless of the type of color film in your camera.

At ice shows, the high reflectivity of the ice does two things. It lightens shadows by bouncing light into them, and it can induce reflected-light exposure meters to recommend camera settings that will underexpose scene elements that are less reflective than the ice. If there are lots of performers in the exposure meter's field of view, enough ice will be covered to negate the problem. However, if you make a reading when there are few performers and a vast expanse of bare ice in view, set the camera for about 1/2 to 1 stop more exposure than the meter suggests. Experience will help you to decide how much correction to make.

If you have a through-the-lens exposure meter system, a good exposure technique to use for performers that are more brightly lighted than the surroundings, such as spotlighted performers, is to put a telephoto lens on your camera. This lets you make close-up readings when you can't get close enough to the subjects to do it with a normal-focal-length lens.

The brilliant colors and intricate designs of stained-glass windows show up best when they are illuminated by daylight shining through them. Use daylight-balanced color film for realistic color rendition.

At ice shows, the surface of the ice is highly reflective and can trick reflected-light exposure meters into indicating camera settings that would underexpose performers that are not as bright. This correctly exposed photograph was made on 400-speed Kodak film, 1/125 second at f/2.8, at Ice Capades, Inc.

Then replace the telephoto with the normal lens to shoot the picture. An overall meter reading for these conditions would overexpose the more brightly lighted subjects. An alternative is to use the exposure in the table on page 43.

Houses of Worship

Some of life's more memorable moments may occur in houses of worship, and unobtrusive existing-light photography lets you preserve them without disturbing the proceedings. A good location to shoot from is the first row of a balcony. You'll have a good overall view and you can rest the camera on a railing for support. Use a normal or wide-angle lens for general views and a fast telephoto or zoom lens to close in on key events near the altar.

Lighting may be daylight or tungsten or both. Choose your film accordingly. With mixed light sources, use a color-slide film that is balanced for the dominant source. If you need prints, a KODAK GOLD or KODAK EKTAR Film will work well with any lighting you're likely to encounter.

You may want to photograph interiors of churches and other houses of worship noted for their architectural beauty or historic significance. A high-speed wide-angle lens will prove invaluable for framing soaring arches, and a medium focal-length telephoto lens will let you isolate details of interest. Stained-glass windows are especially picture-worthy. They look best when photographed from inside the building, with daylight shining through them. Make a reflected-light reading of

the window only, excluding darker surroundings that could result in overexposure. If you cannot make a close enough reading or your exposure meter is not working properly, try an exposure 3 stops greater than what you would use for the outdoor lighting conditions. For example, with the sun shining on the window and an ISO 400 film, instead of exposing for 1/500 second at $f/16$ as you would outdoors in bright sunlight, expose the stained-glass window from inside for 1/125 second at $f/11$.

Whenever you plan to take photographs in a house of worship, it is a good idea to make sure that it won't offend anyone or violate a deeply held religious belief. If a ceremony is in progress, be as inconspicuous as possible so you don't distract the proceedings. If you attend a wedding where a professional photographer has been engaged, don't let your picture-taking efforts interfere with his or hers. There will be more than enough picture opportunities for everyone.

Existing-Light Photography En Route

When you're traveling, your mode of transportation itself may provide some fond memories. Take pictures of friends, family, and other companions en route in motor vehicles, trains, planes, and boats to help complete the photo story of your trip. No means of transportation is too far out. Even astronauts photograph each other in flight.

Daylight transmitted through windows and portholes is the best light source and is usually bright enough to allow using reasonably high shutter speeds with fast films. Use daylight-type color films unless the vehicle has deeply tinted windows. In that case, use black-and-white film or take pictures with flash. Select the fastest shutter speed conditions permit, because motion of a vehicle causes random, unpredictable camera movement. Hold your camera as steady as you can, and take pictures during smooth intervals—not when you're on cobblestone paving or in rough air! To prevent vibration from degrading image quality, don't brace your hands, arms, or your camera against any part of the vehicle. Normal exposure-metering techniques work well except when a window is behind the person you're photographing. In this situation, make a close-up reading of the subject.

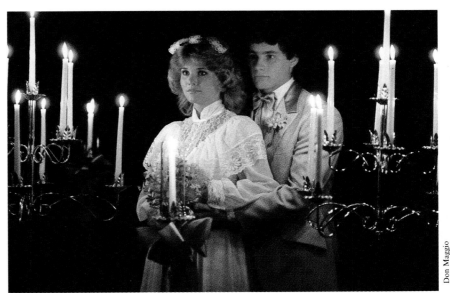

Don Maggio

Houses of worship are the settings for many of life's memorable events, which are natural subjects for unobtrusive existing-light photography. Here 1000-speed film was used. Exposure was 1/125 second at f/4.

Bruce Nett

Keep your camera on hand en route to record additional aspects of a trip. Daylight coming through the windows of an airliner was bright enough for an exposure of 1/125 second at f/4 on 400-speed Kodak film. Expose at the highest practical shutter speed, considering depth-of-field requirements, to counter motion and vibration.

83

School Events

Whether you're a parent or a student, school events such as parties, dances, award ceremonies, concerts, plays, and athletic competitions are rich in picture subjects. These events are memorable occasions, which make the pictures you take valuable, especially when family members are participants. Light sources may include window light during the day or tungsten, fluorescent, or high-intensity discharge lamps in areas that are nor-

Daylight and fluorescent, 1000-speed Kodak film.

Daylight and tungsten, 400-speed Kodak film.

Be ready for varied lighting when you photograph school activities. You may find daylight, tungsten illumination, and fluorescent tubes separately or together. If you haven't visited the school, check ahead of time to determine the type of lighting.

mally illuminated by artificial lights. If you aren't familiar with the area where you expect to be making pictures, make a telephone call to school authorities ahead of time. They can usually give you information about the type of lighting. Then choose a film for the correct color balance. See the chapter on Kodak films. If you're taking pictures for a school newspaper or yearbook, black-and-white is the usual requirement, so you'll want to use a high-quality black-and-white film well suited for existing-light photos. T-Max 400 and T-Max P3200 Professional Films are excellent choices.

Indoor Sports

Sports action, professional or amateur, offers abundant opportunities to take exciting photographs. Find out in advance the type of lighting in use and choose color films to match. You should favor high-speed films. In tungsten lighting, push processing 160-speed tungsten film by 1 stop gives higher speed and better stop-action capability.

If your seat or shooting location is far from the playing area, a medium telephoto lens can bring the action closer. Lenses

Indoor sports are most easily captured with high-speed film and fast lenses.

You can blur motion deliberately to emphasize speed. Simply select a shutter speed or exposure time too slow to stop the action. See the table on page 24. This photograph was made on KODACHROME 25 Film (Daylight), 4 seconds, f/4, while panning the subject.

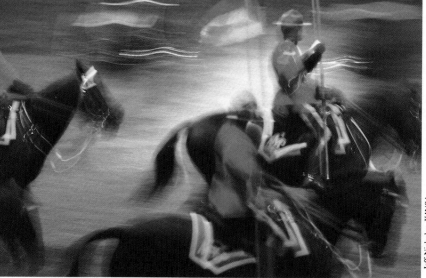

with large maximum apertures are best. Use high shutter speeds to stop subject and camera movement. For the most dependable exposure-meter readings, make close-up reflected-light or incident-light readings in the playing area beforehand. If that isn't possible, take care that reflected-light readings you make at a distance don't include excessive amounts of darker areas, such as sidelines and bleachers, or lighter areas, such as ice. If the playing surface is unusually light and affects the meter reading, increase exposure about 1/2 or 1 stop more than the meter indicates. Set the exposure before the action starts so that you won't have to fiddle with camera controls during key moments when you should be devoting total attention to your subjects. If the playing area is lighted unevenly, note basic exposure settings to use in important lighter and darker zones. Don't worry about lighting variations of less than 1 stop.

In light levels where you can't use high shutter speeds, shoot during momentary pauses or peaks in the action, such as the top of a basketball player's jump. Also remember that you can stop movement directly toward or away from you with slower shutter speeds than you need for movement crossing the field of view. You can capture rapid lateral motion dramatically by panning with it, as described on page 24. And don't overlook the possibility of making dramatically different motion shots in which the moving subject's speed is emphasized by deliberate blurring. To do this, use a shutter speed too slow to stop the moving subject, or for even more blur, pan the camera *opposite* the subject's direction of motion during the exposure. Experiment to find the shutter speeds and the panning motion that produce effects you like.

At sports events, it's easy to become totally involved with the action on the field. Nonetheless, keep an eye out for interesting picture possibilities in the stands, too. The antics of fans, their expressions when a favorite team or player scores or muffs a shot, the activities of refreshment and souvenir vendors, and the actions of the fans when the game ends all contribute to the overall spirit of the event. Look for these "bonus" subjects, because they sometimes prove more interesting than the players themselves.

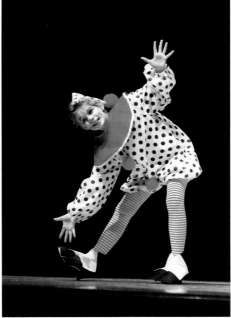

Ed Austin

Semi-close-up views of performers are especially rewarding. A medium telephoto lens helps bring you closer to the spectacle.

Stage Performances

You can make memorable photographs at plays and musical performances whether the stars are international celebrities or your neighbors from down the block. The front row of the balcony offers the best vantage point; you don't have to contend with heads blocking your view. In a large theater, bring along a medium telephoto lens to close the distance. From a strictly photographic standpoint, a dress rehearsal is preferable to an actual performance because you can move about discreetly to frame your shots to best advantage and you don't have to worry about interfering with other members of the audience. Stage lighting is compatible with tungsten color-slide films. EKTACHROME 160 Film (Tungsten) is a good choice. Its ISO 160 speed permits camera settings of approximately 1/60 second at $f/4$ for professionally lighted stage presentations. If you need more speed to stop dancers or rapid on-stage action, you can push-process the film to increase the speed by 1 or 2 stops as discussed on page 56.

Determining exposure for stage spectacles is best done ahead of time during a rehearsal with full lighting. Incident-light readings or close-up readings with a reflected-light exposure meter on stage are ideal. Reflected-light readings from the orchestra or balcony with a spot meter can be very accurate, too, provided you pin the spot on significant subject tones. Since light levels and effects may change frequently in the course of a performance, note in the program the exposure settings required for each scene or act. Stage lighting is often deliberately uneven to direct attention to specific areas of the stage. Set the exposure to favor the important areas where the action takes place. Don't worry about minor fluctuations in light level of 1 stop or less. If you cannot make exposure readings in advance, rely on the suggested exposure data in the table on page 43 or on meter readings made during the show. Do not rely on reflected-light meter readings made from too far away from the stage that include the dark surroundings of the audience and the theater.

Since you will generally be photographing at a moderate distance from the stage, depth of field is likely to be adequate even at fairly wide lens apertures, so don't hesitate to use shutter speeds fast enough to stop action. In subdued lighting, wait for peaks or lulls in stage activity, as you would at a sports event.

During an actual performance, don't let your photographic activities interfere with other audience members' enjoyment of the show. At recitals and concerts, don't trip the shutter during very soft passages or pauses. The click can be surprisingly disconcerting in a hushed hall. If you have a motor drive or autowinder, leave it at home because of the distracting noise these accessories generate.

A bonus of taking existing-light pictures is that you'll be less disruptive to the performance. This also means you won't be using flash. Taking flash pictures in a theater is very distracting to both the audience and the performers. Do not use flash unless express permission is given by the theater management. Better yet, leave your flash unit at home.

Take along a pen-type flashlight for checking camera settings and reading notes you've jotted in the program. At professional theaters and concert halls, all photography may be prohibited during performances. When that is the case, it is usually stated in the program. If you're not sure, ask theater personnel before curtain time and explain that you won't be using flash. Or make arrangements to take pictures during a dress rehearsal when you'll have much more freedom to move around.

Stage lighting is often uneven by design, to highlight performers and heighten drama. In general views, such as this one made on EKTACHROME 160 Film (Tungsten), 1/60 second, f/2.8, expose for the medium-tone and bright areas. When you focus in on details with a telephoto or zoom lens, adjust exposure to suit the specific area. Nutcracker Suite, courtesy New York City Ballet.

Lighting for floor shows can vary in color from moment to moment. When colored lighting effects or other light sources are part of the spectacle, don't worry about precise color balance because the pictures will likely be attractive and realistic.

Nightclubs and Restaurants

A festive night out in your hometown or on a trip offers existing-light picture possibilities in restaurants, cafés, or nightclubs. Lighting is normally tungsten and on the warm side to flatter patrons' complexions and look inviting. It is often dim to create an intimate atmosphere, so take a fast tungsten-balanced color slide film. Or use a high-speed color print film. Any of the Kodak black-and-white films with an ISO speed of 400 or faster is appropriate for black-and-white prints.

Shooting distances are likely to be short to moderate, so stick to normal or wide-angle lenses with large maximum apertures unless you suspect you will be seated far from an interesting floor show. In that case, a medium telephoto will be helpful. If you have to use shutter speeds

Shooting distances are likely to be short to moderate, so stick to normal or wide-angle lenses with large maximum apertures unless you suspect you will be seated far from an interesting floor show. In that case, a medium telephoto will be helpful. If you have to use shutter speeds

slower than 1/60 second, brace your camera on anything that's steadier than you are. Don't be overly concerned about color balance. A spectacular picture of the maître d' flaming crêpes suzettes or of fancifully costumed dancers whirling under multi-colored spotlights will be accepted as is, with no quibbling about whether or not the color balance is less than optimum.

If the lighting is uneven, as is often the case, use exposures that favor middle-tone and highlight areas. Be careful not to "trick" your meter by aiming it at candles on the table or bright lights while making exposure readings. When in doubt, bracket. And don't be discouraged by rapid and essentially unpredictable changes in lighting during floor shows. Compensate as best you can and keep on shooting. Your goal, after all, is not to create a clinically precise record, but rather a memento of the moment. Take a penlight flashlight along to help you see your camera settings in the dim light.

Caroline Grimes

Expositions of all kinds are good stalking grounds for existing-light pictures. Lighting varies widely, and individual exhibits may be lighted differently from surrounding areas. If you shoot color slides, take tungsten- and daylight-balanced films to cover all possibilities. The photograph of a custom car show was made on EKTACHROME 160 Film (Tungsten) with Push-1 Processing, ISO 320.

Hobby and Trade Shows

Hobby and craft exhibitions, flower shows, business and trade shows, consumer-oriented automobile and boat shows, and expositions of all kinds are interesting places to take existing-light pictures. Lighting may be tungsten, fluorescent, or even Multi-Vapor or mercury vapor overall, and individual exhibit areas may have lighting that differs from the general illumination. If you cannot find out in advance what the predominant light source is, hedge your bets by taking daylight- and tungsten-balanced color-slide films or a high-speed color-negative or black-and-white film. Light levels are usually high enough to permit

photography with a hand-held camera. No special metering techniques are normally required.

A lens that permits close focusing or a simple supplementary lens attachment that extends the close-focusing ability of a fast-normal or medium telephoto lens will let you move in and make eye-catching close-ups of interesting details. Focus carefully and hold the camera steady when shooting close-ups. If possible, brace the camera on a firm support.

Besides photographing the displays, keep an eye on the interaction between exhibitors and visitors to add a human dimension. Also be on the lookout for good shots of people reacting to the dis-

plays. You could make a charming picture story, for example, by recording the expressions of children at a toy show or exhibitors grooming their pets at a dog show. Just be ready with your camera and an ample supply of film. The rest is a matter of careful observation and patience.

When you attend a meeting or a lecture, you can use existing-light techniques as a visual form of note taking. You can photograph displays, demonstrations, blackboards, and slides on a screen. Choose color or black-and-white film for your needs. For color slides of projected images, generally tungsten film is the best choice.

Recommended reading

This book has presented a practical approach to existing-light photography. You may find that you want some additional knowledge, and Kodak books can help you to polish your photographic skills. Some books describe basic or advanced techniques, and some give great detail about the characteristics and use of Kodak products. Review the list of books that follows for topics that are of interest to you.

Kodak books are available on a wide range of creative and technical photographic topics for both amateurs and professionals. Ask your photo dealer about Kodak books or contact:

Silver Pixel Press®
A Tiffen® Company
21 Jet View Drive
Rochester, NY 14624
Fax: (716) 328-5078
www.saundersphoto.com

Professional Photographic Illustration
O-16, ISBN 0-87985-756-0

Large-Format Photography, O-18e
ISBN 0-87985-771-4

The Portrait, O-24
ISBN 0-87985-513-4

Winning Pictures—101 Ideas for Outstanding Photos, AC-200
ISBN 0-87985-761-7

KODAK Guide to 35mm Photography
AC-95, ISBN 0-87985-801-X

KODAK Pocket Guide to 35mm Photography, AR-22
ISBN 0-87985-769-2

KODAK Professional Photoguide, R-28
ISBN 0-87985-798-6

KODAK Black-and-White Darkroom DATAGUIDE, R-20
ISBN 0-87985-602-5

KODAK Color Darkroom DATAGUIDE
R-19, ISBN 0-87985-611-4

How to Take Good Pictures, AC-36
ISBN 0-345-39710-X

Index